BRIGHTON FOLK

PEOPLE WATCHING, FOR SPORT

OLEG PULEMJOTOV

BRIGHTON FOLK

FOLK PEOPLE WATCHING, FOR SPORT

The History Press

First published 2020

The History Press
97 St George's Place
Cheltenham, Gloucestershire, GL50 3QB
www.thehistorypress.co.uk

British Library Cataloguing in Publication Data.
A catalogue record for this book is available from the British Library.

ISBN 978 0 7509 9298 5

Typesetting and origination by The History Press
Printed and bound in Europe by Imak

Thank you, Brighton,
for making me feel at home.

INTRODUCTION

Brighton has a reputation – it's all true. The hippies and the hipsters; the daily commuters; the hens; the beach; the Green Party; the secret Tories; the gays; the activists; the hummus; the seagulls; the drunks and the drugs – all of it. But there is much more to Brighton than that.

After my first visit to Brighton, I remember feeling quite fascinated and intimidated at the same time. Our train got in late and we headed straight down to the seafront, where we stayed up all night. On the way back to London, I just could not fathom how anyone could possibly keep up with the city's energy.

That was fifteen years ago and I know better now – West Street on a Friday night and the beach after 3 a.m. are hardly a representation of Brighton as a whole.

After visiting a few more times and falling in love with the place, I moved to Brighton in 2009. Like many, I was won over by the art scene and promises of infinite fun. It is not hard to see how much contrast the city has to offer, how quickly it evolves, yet how well everything fits together. How one moment it is peaceful and quiet, the next it is brimming with teenage English language students, Great Escape ticket holders, EDL marchers, or flying ants. How you can't get a spot on the beach as soon as the weather goes above 12°C. How young university students weave in and out of the ageing locals.

It is this delicate balance that I am fascinated by and endeavour to explore in this book.

Brighton Folk did not start off as a project straight away. I was just getting into photography around the time I moved to England. Everything I saw was new to me and I wanted to capture it all and keep it like a souvenir. My dad had just given me his camera and, without exception, I took it with me everywhere I went.

It wasn't until a couple of years later, when taking a step back to review the photographs, I realised there was a group of them that stood out to me. Looking at them I saw a collection of moments of genuine Brighton authenticity, the way it appeared to me. I felt compelled to delve deeper into it, and that is how this street photography book was born.

ABOUT THE AUTHOR

Oleg was born to Russian parents in a small Soviet mining town in eastern Estonia. At the age of 15 he moved to America as a foreign exchange student, where he remained for the following seven years. During that time, he finished high school in Kansas, graduated from university in Minnesota and worked as a graphic designer in Chicago.

Having visited England a few times already, mostly on summer breaks from studies, Oleg moved to London in 2008 and finally settled in Brighton a year later. It was around this time that he picked up a camera. He used it as a tool for familiarising himself with the city, learning about English culture and meeting new people. Armed with an old Zenit Olympic edition 35mm, he learned the basics of aperture, shutter speed and focus, and began his journey as a street photographer. Eventually, Oleg submerged himself in the Brighton music scene by becoming a live music and band photographer. This gained him recognition from many musicians, record labels and local magazines. Oleg started his 'Brighton Folk' series back in 2011 and had his work featured in *Brighton Source*, *Viva Brighton*, and as part of the Brighton Photo Fringe.

Completely self-taught, Oleg's approach to photography is a combination of always having his camera ready and his compulsion to keep exploring. His graphic design background gives him an artistic edge and an eye for composition and space.

Bright•on | ˈbrītn |

a resort town on the southern coast of England; pop. 133,400.

folk | fōk | (also folks)

plural noun
1 informal people in general : *some folk will do anything for money* | *an old folks' home.*
 a specified group of people : *some city folk cringe at the notion of consuming these birds.*
 (**folks**) used as a friendly form of address to a group of people : *meanwhile, folks, why not relax and enjoy the show?*
 (**one's folks**) the members of one's family, esp. one's parents :
 I get along all right with your folks.
2 folk music : *a mixture of folk and reggae.*

1 adjective [attrib.] of or relating to the traditional art or culture of a community or nation : *a revival of interest in folk customs* | *a folk museum.*
 • relating to or originating from the beliefs and opinions of ordinary people: *a folk hero* | *folk wisdom.*
2 of or relating to folk music : *performing at a folk club in Chicago.*

(Source: *The Oxford Dictionary of English*)

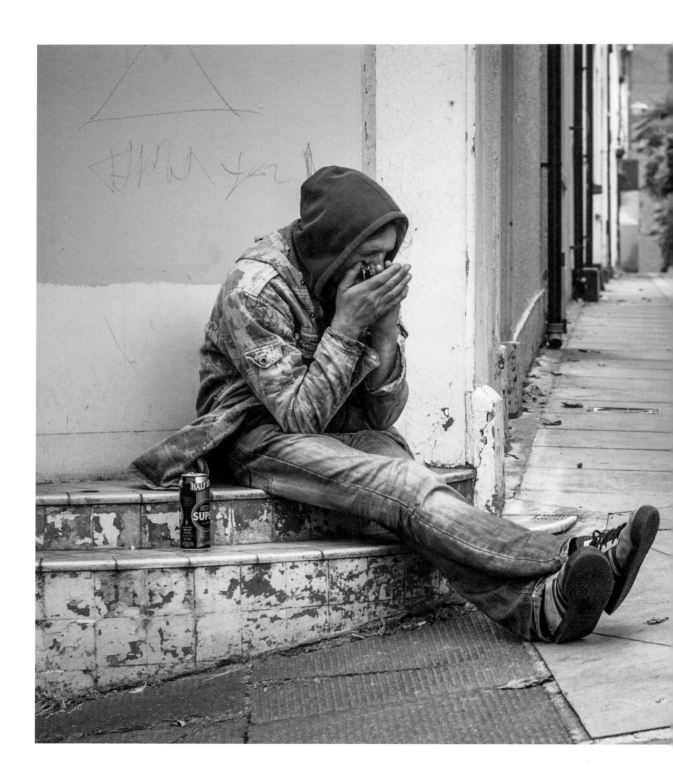

Folk music

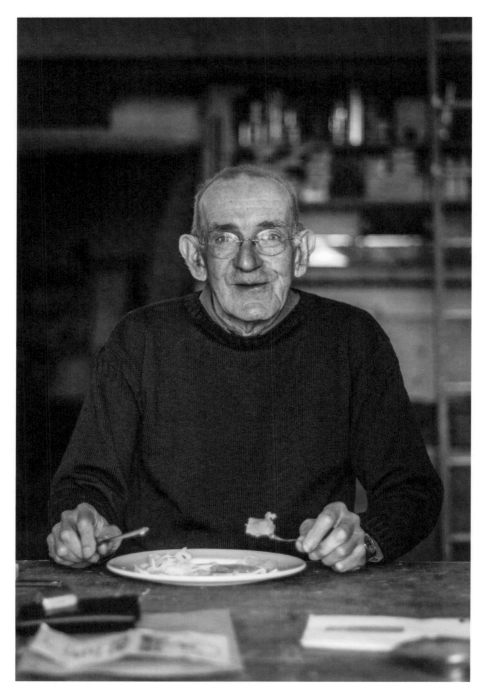

Fisherman's friend
Andy Durr, creator and custodian of the Brighton Fishing Museum, 1944–2014

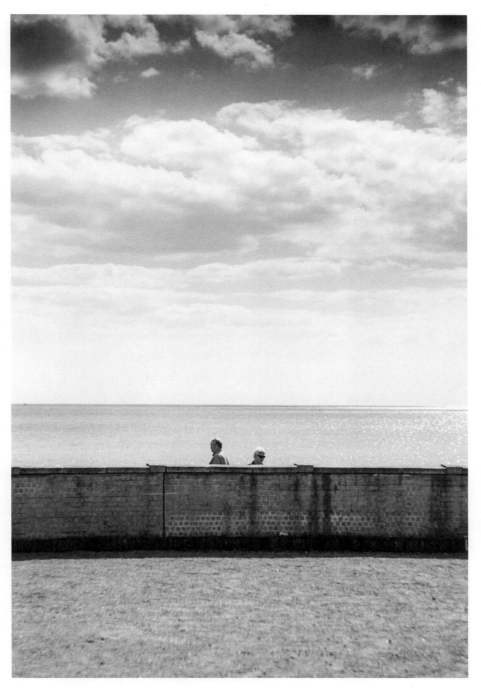

Ships passing in the night

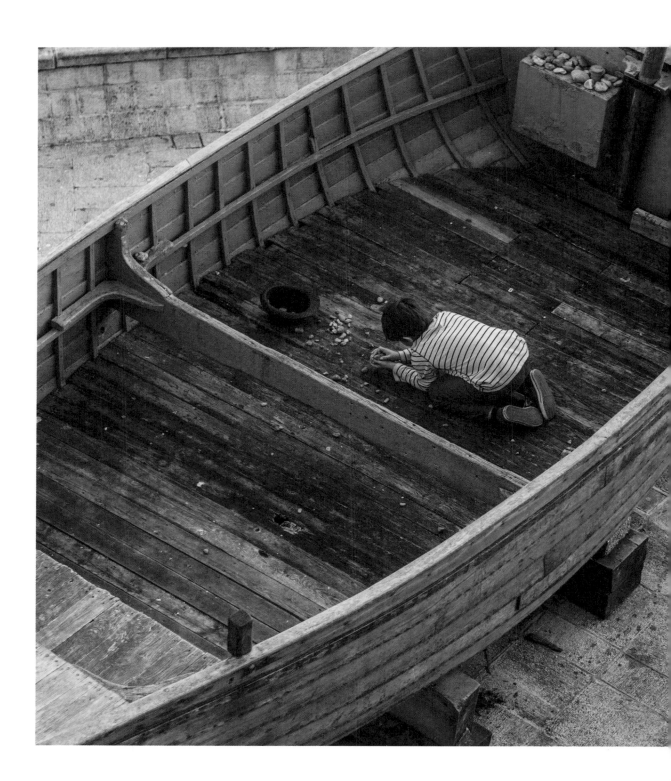

LEFT:
Pebble collector

OVERLEAF:
Skylark

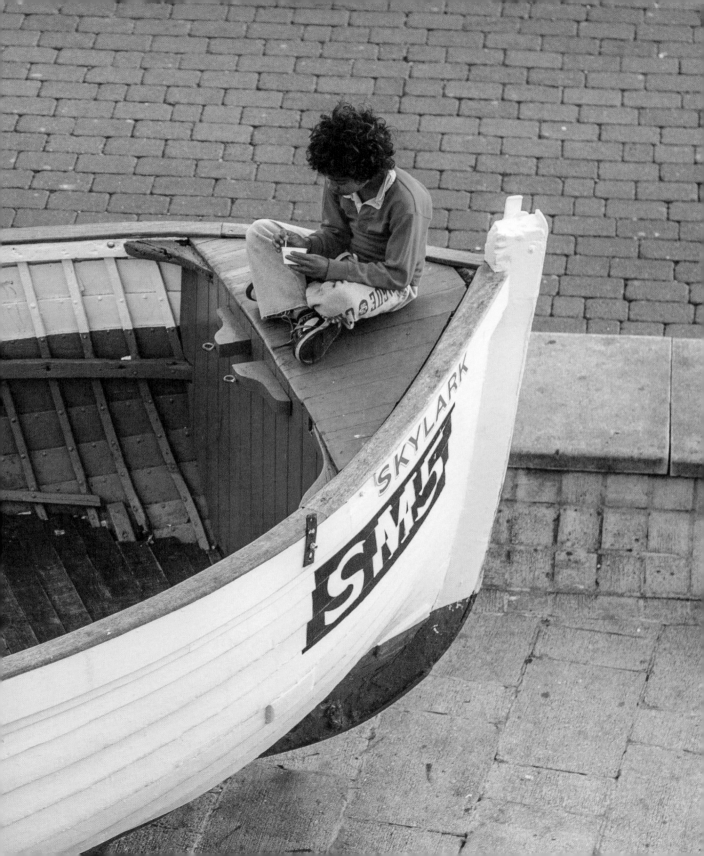

Mural

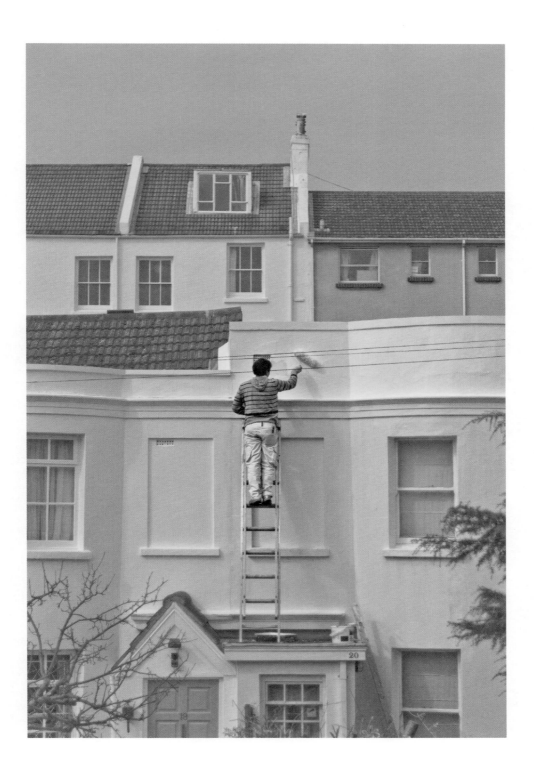

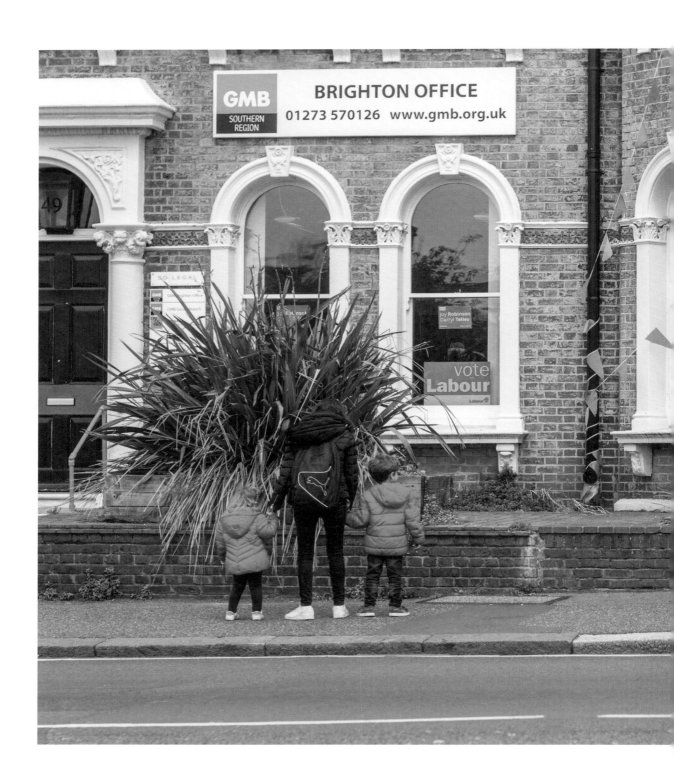

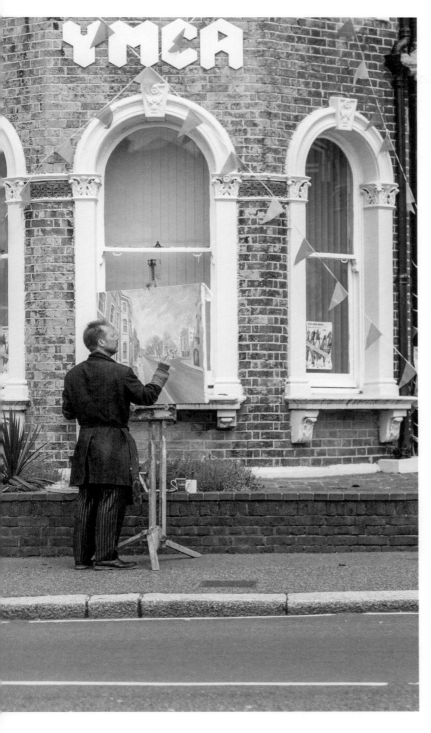

Pauly the Painter

Pebble collector II
Brighton beach leaves an impression on most people

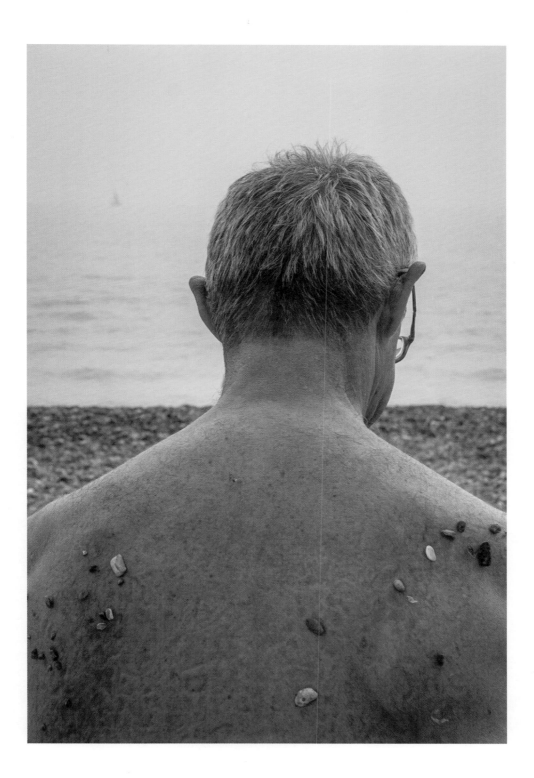

RIGHT:
Remedies

OVERLEAF:
Catch-up

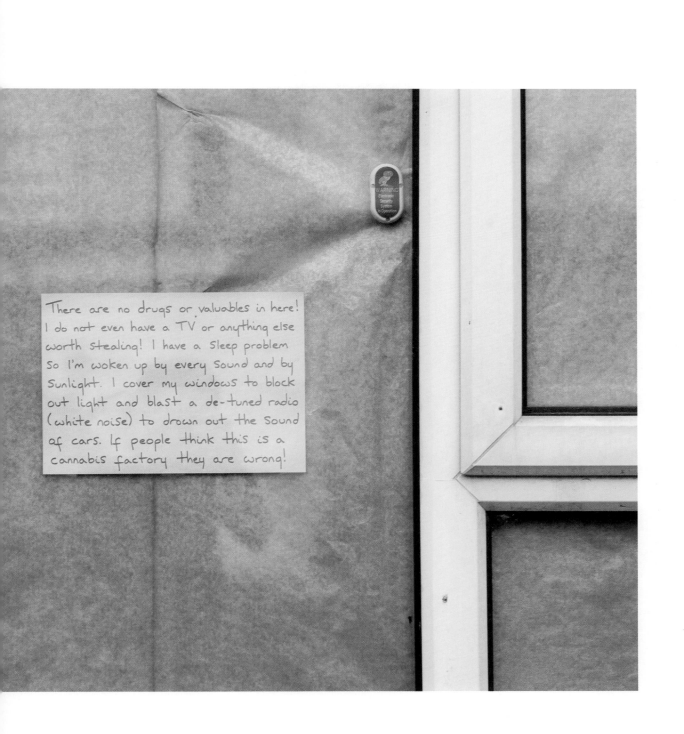

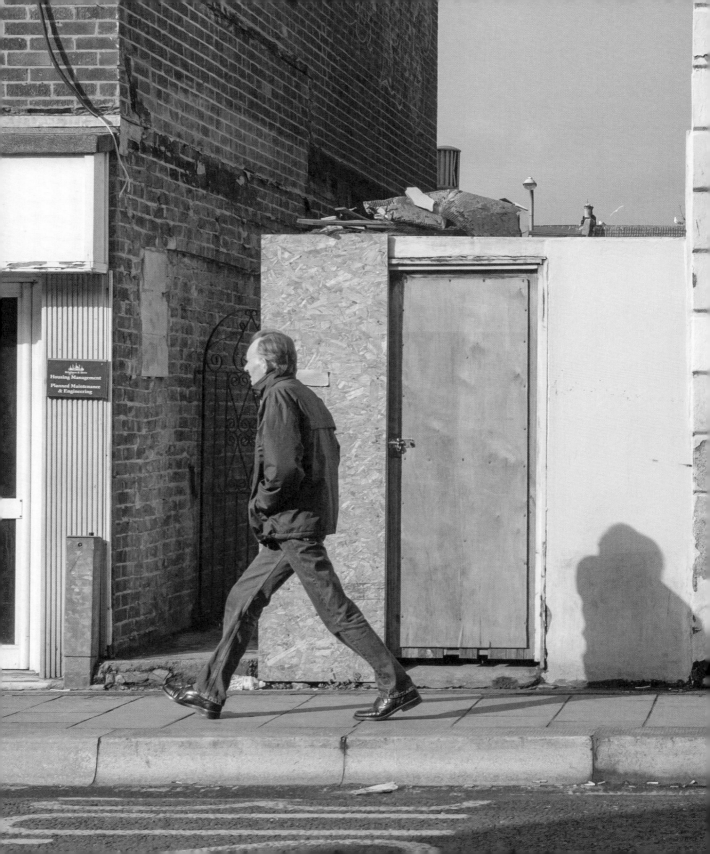

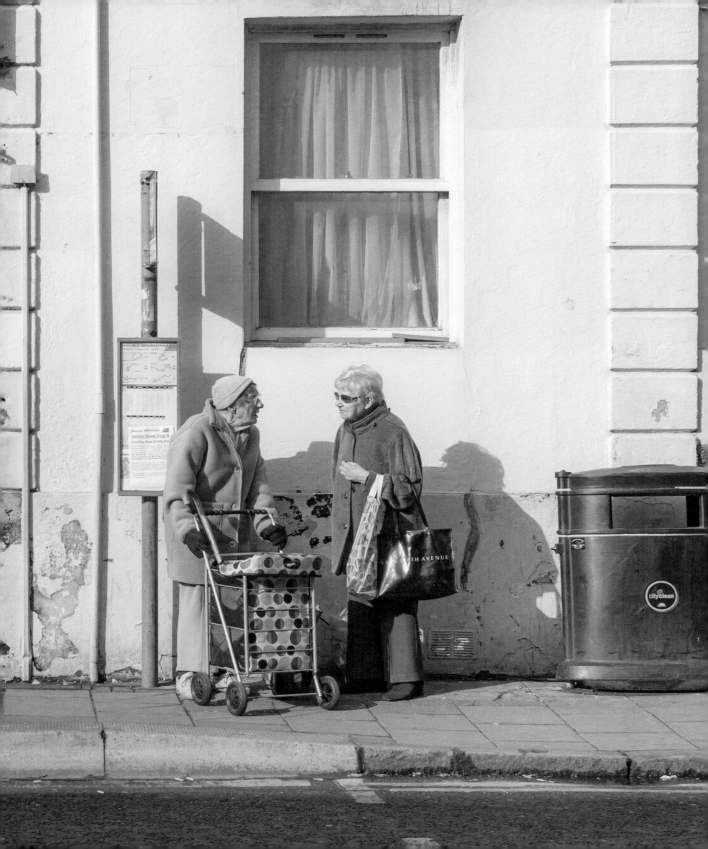

Disco Pete
Brighton legend, dancing
tirelessly anywhere
there is music

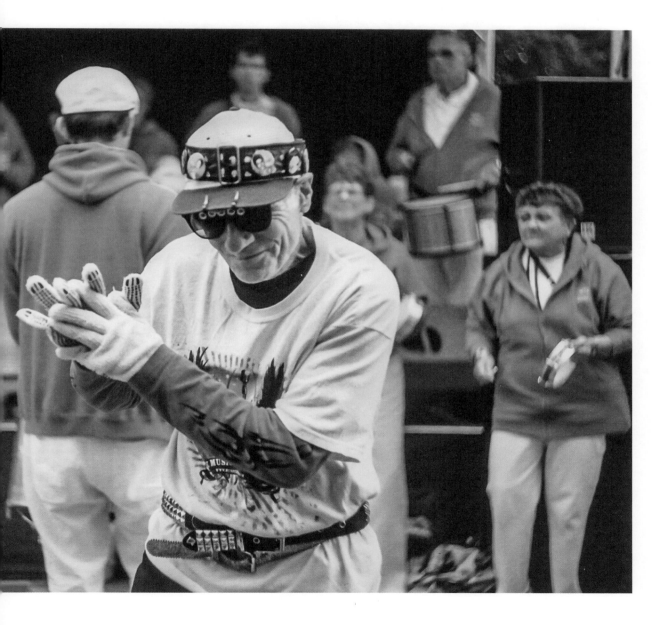

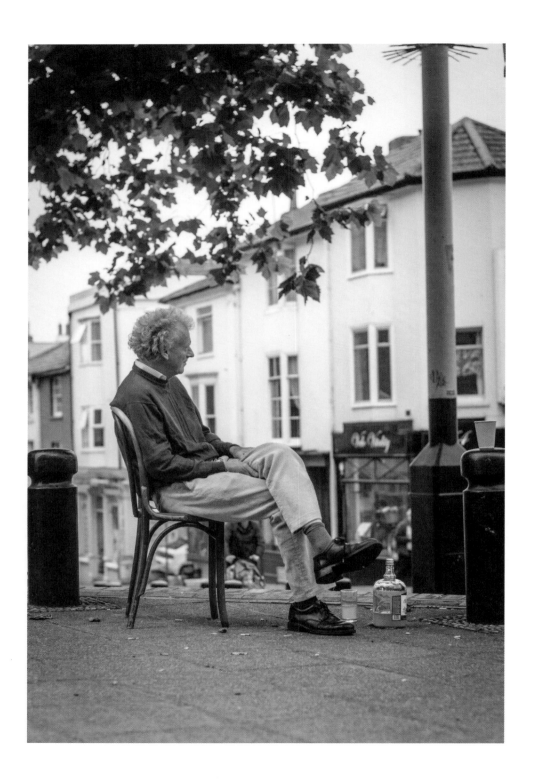

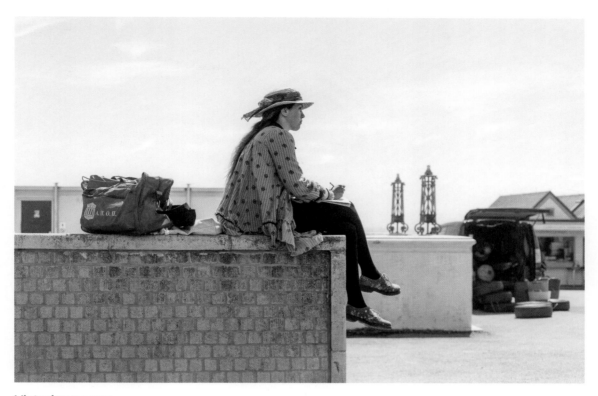

Victorian poems

OPPOSITE:
Book salesman

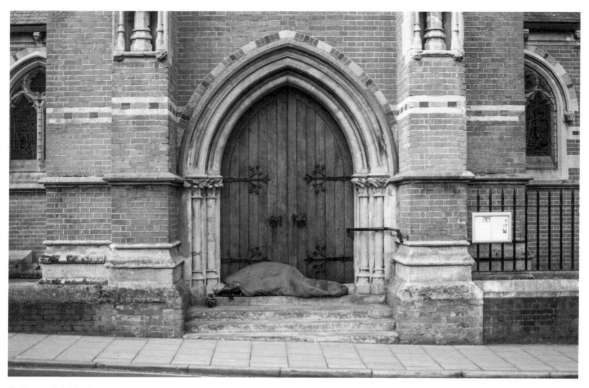

3 June 2019, 8:32:03

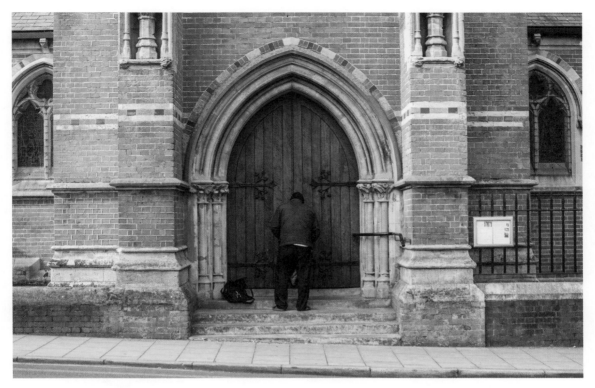

6 June 2019, 8:32:52

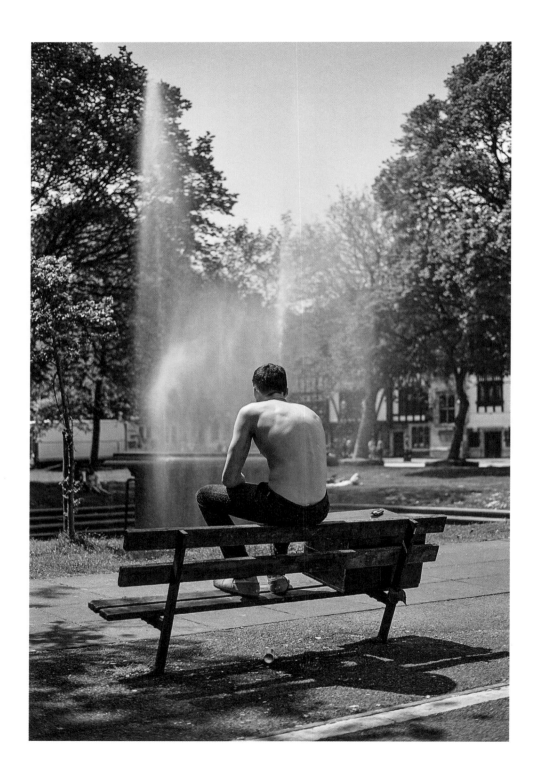

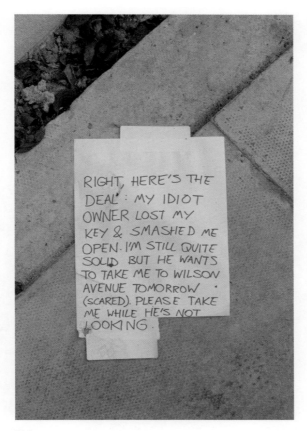

Taken

OPPOSITE:
Upperdecker

OVERLEAF:
Patches

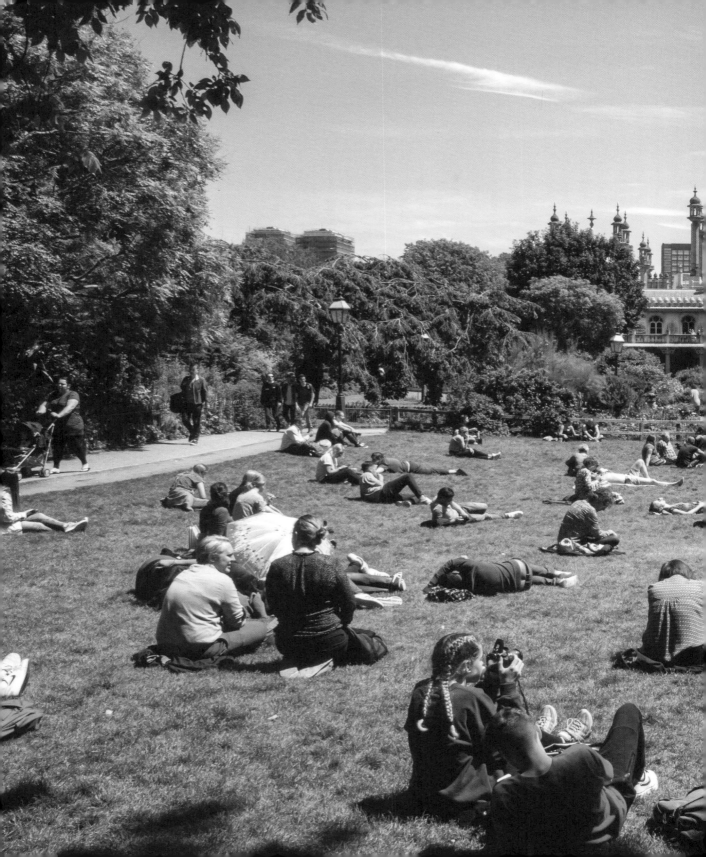

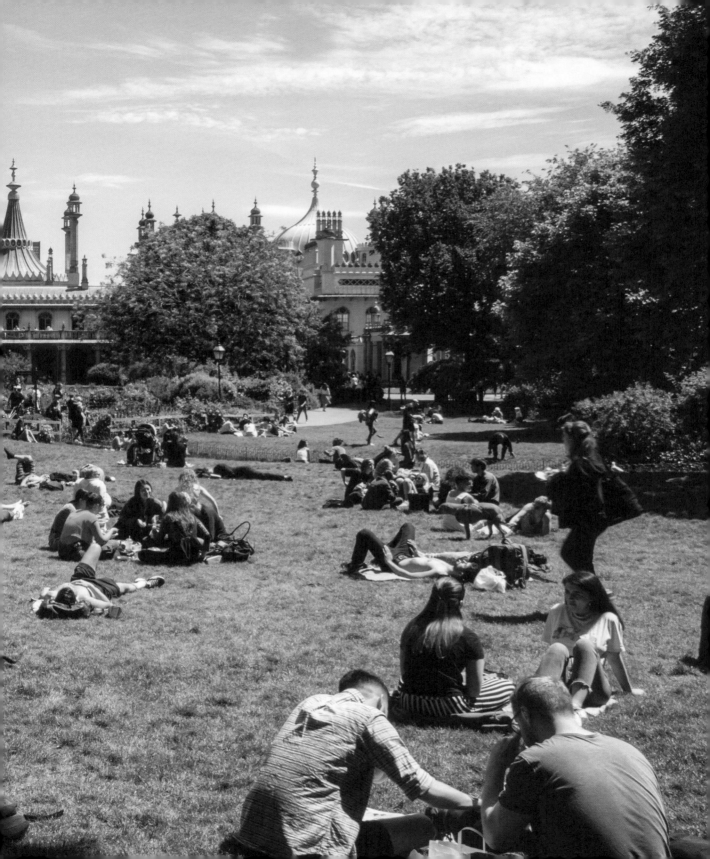

Space Invader

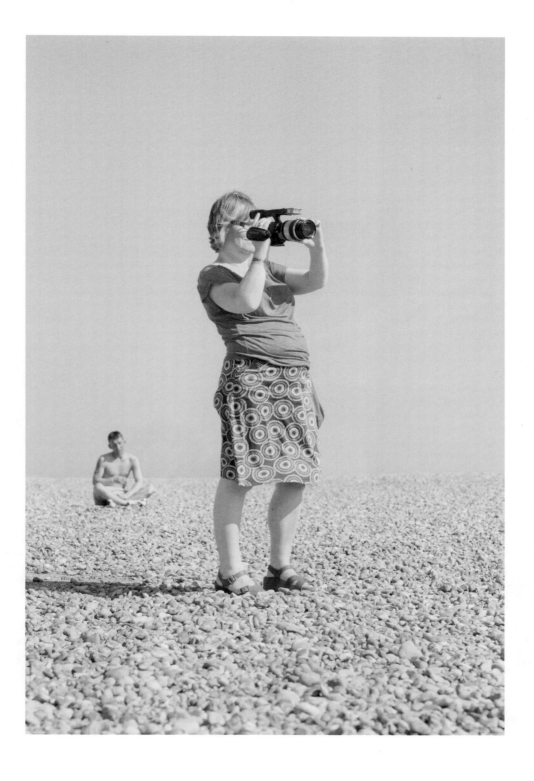

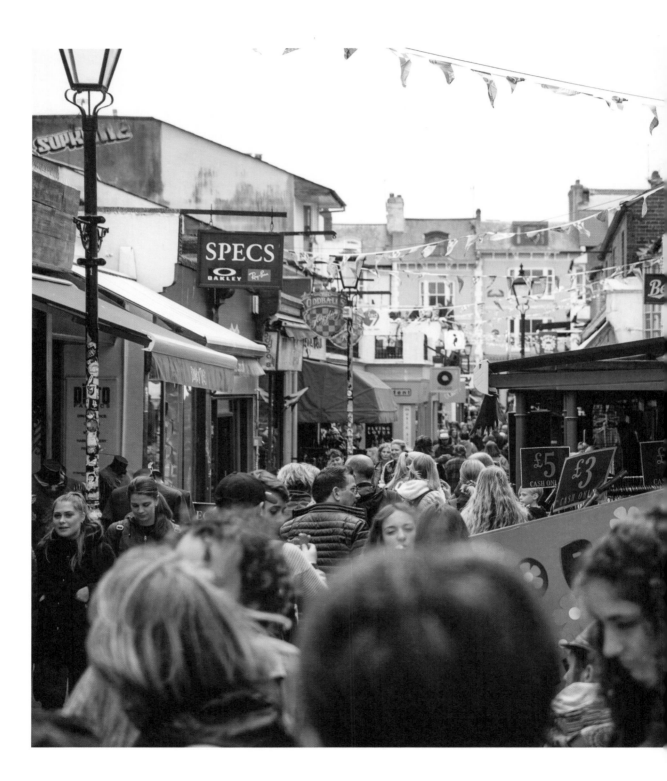

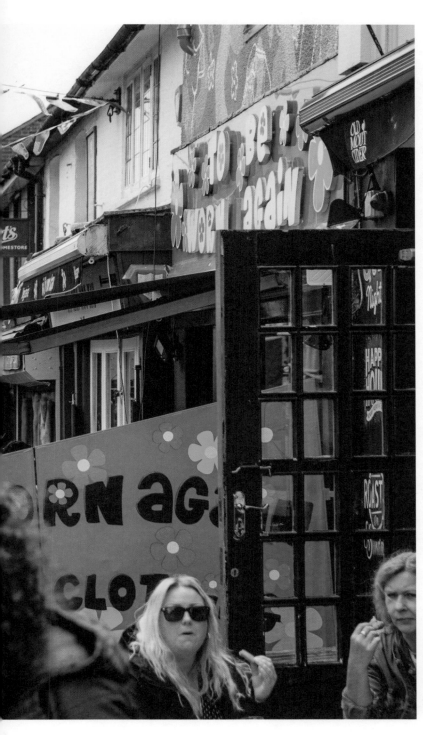

LEFT:
Kensington Gardens

OVERLEAF:
Crescent moon
Crowd gathered around Queen's
Park pond waiting for the
moon to be switched on

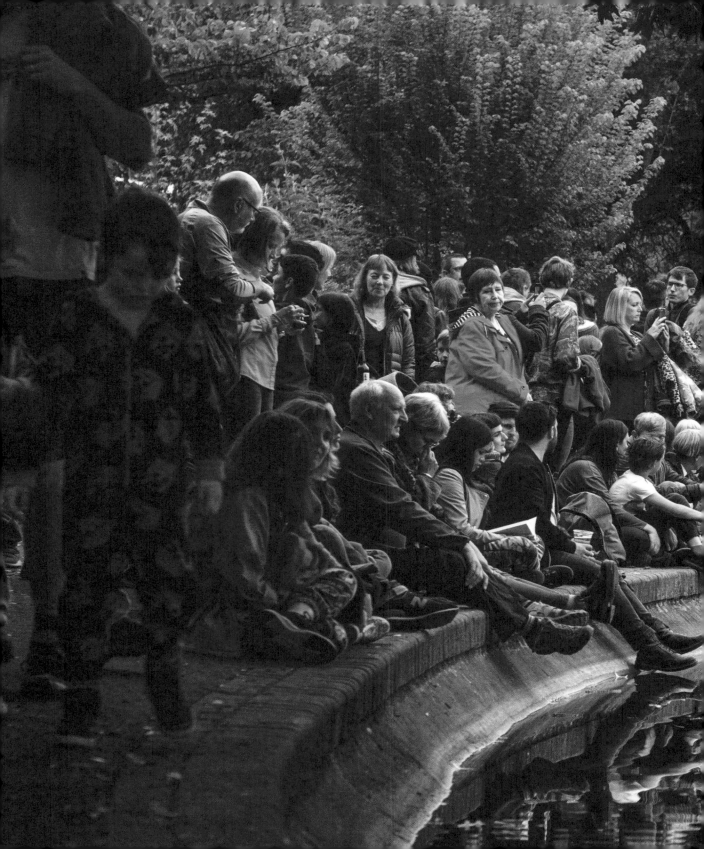

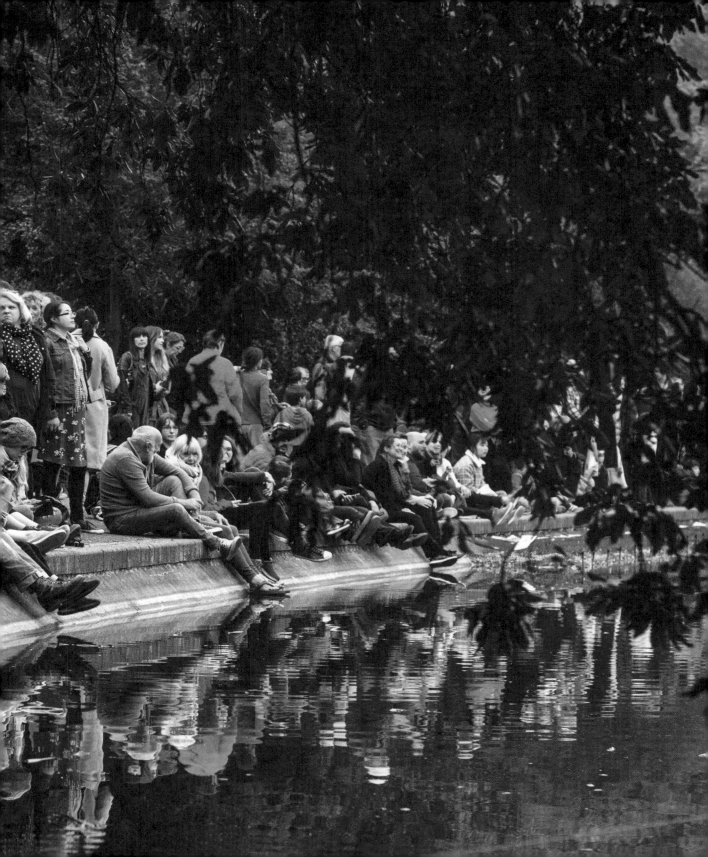

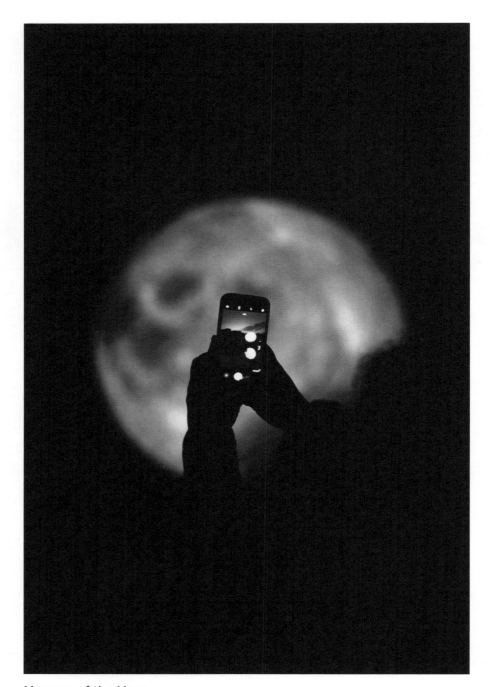

Museum of the Moon
Luke Jerram's touring artwork installed above Queen's
Park pond as part of the annual Brighton Festival

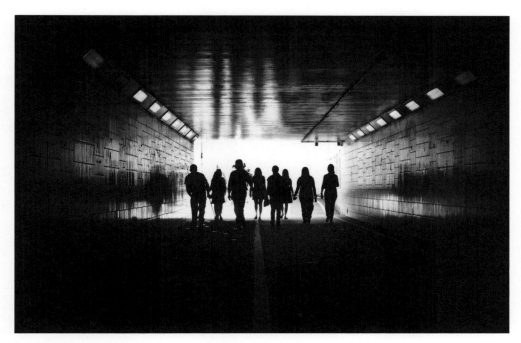

Tunnel vision

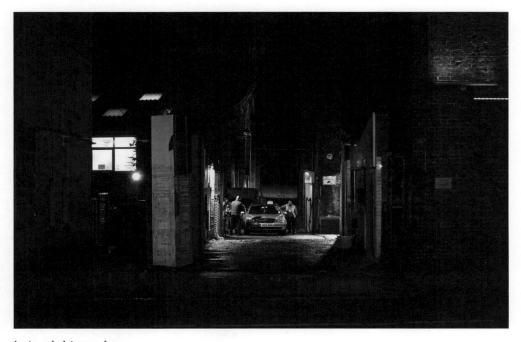

Late night service

King and Queen

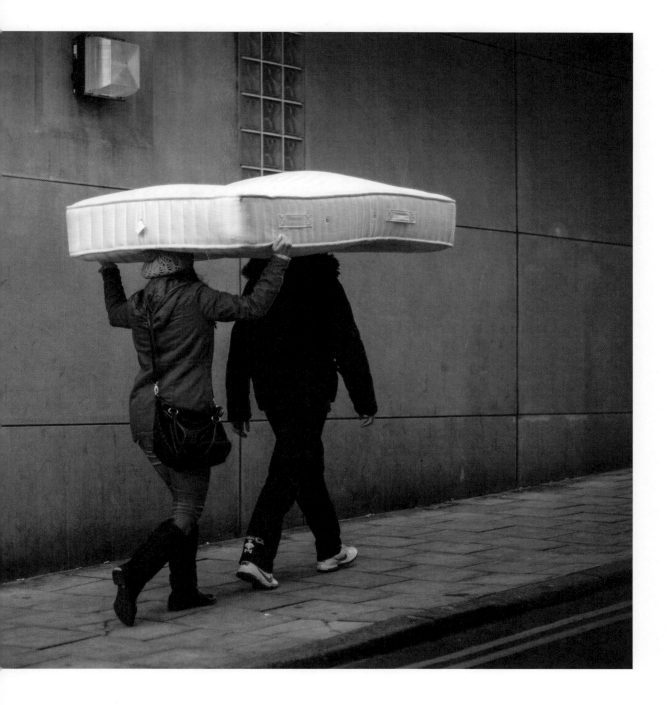

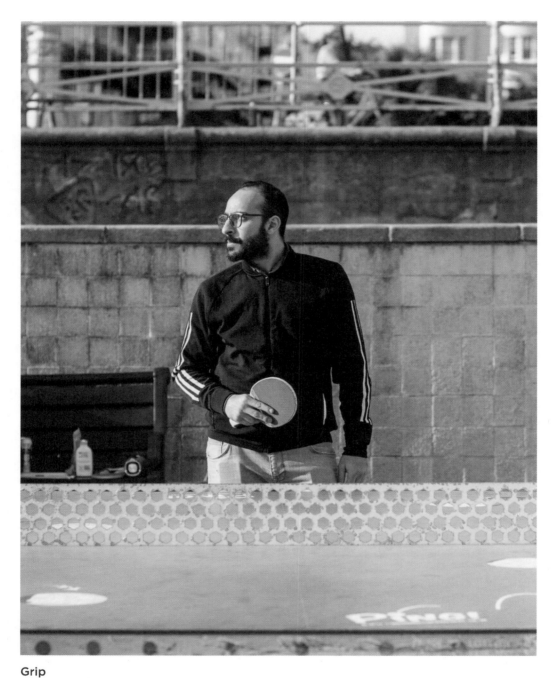

Grip

OPPOSITE:
Learning to fly

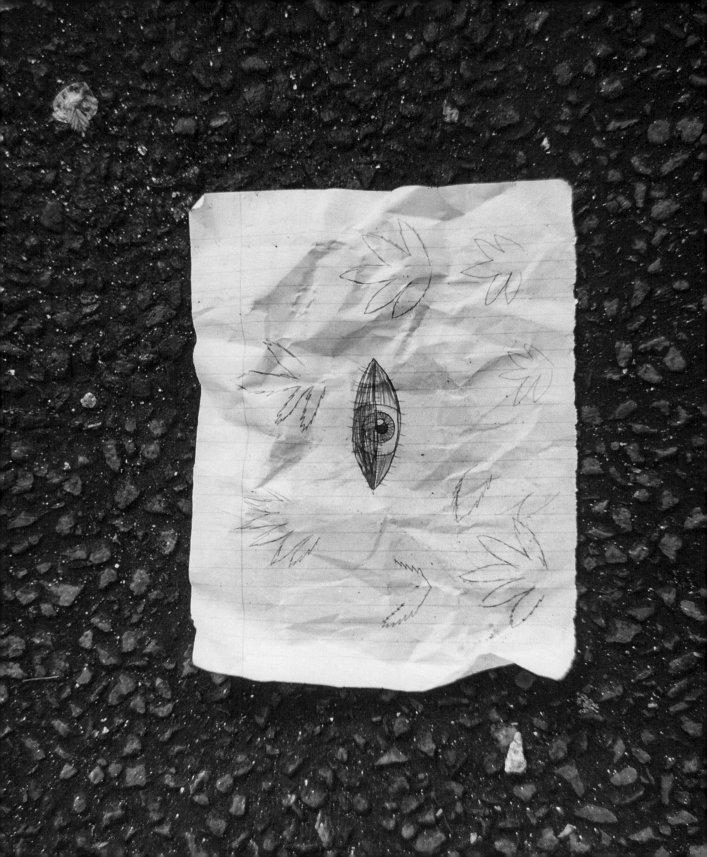

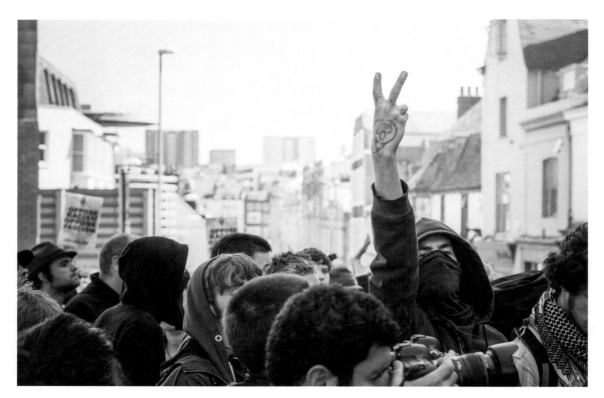

Red sky in the morning

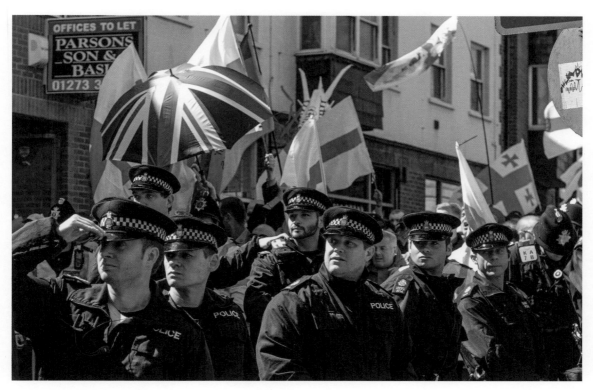

Shepherd's warning

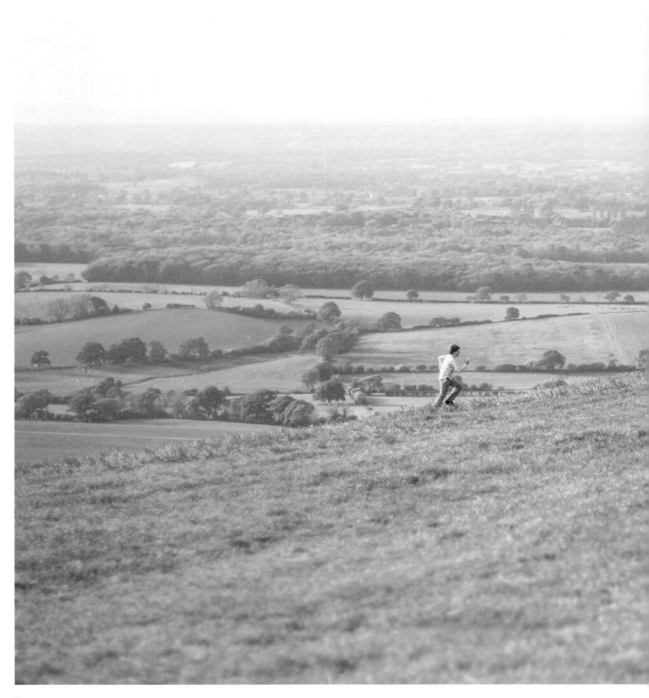

Run up

You wot?

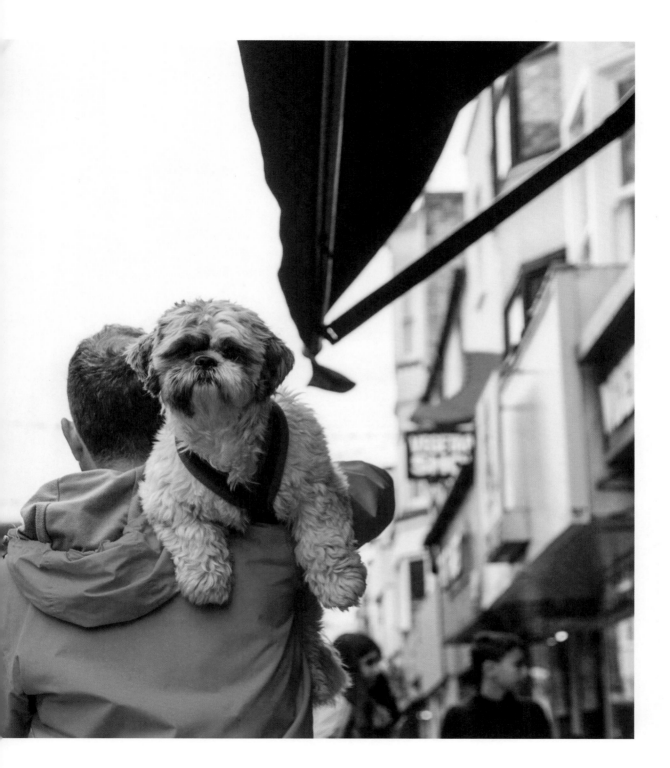

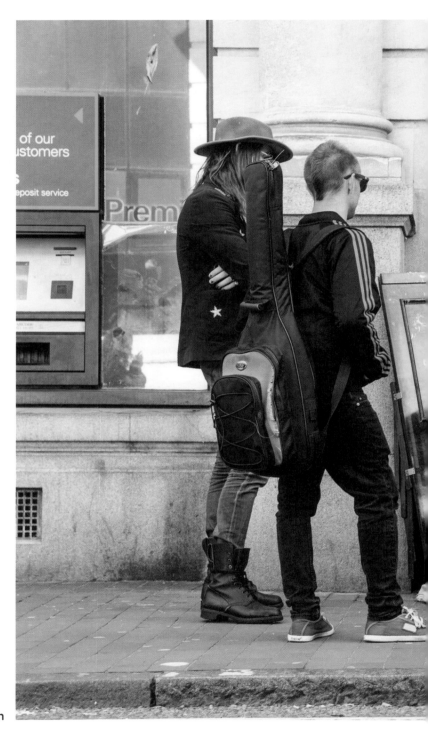

Listen and learn

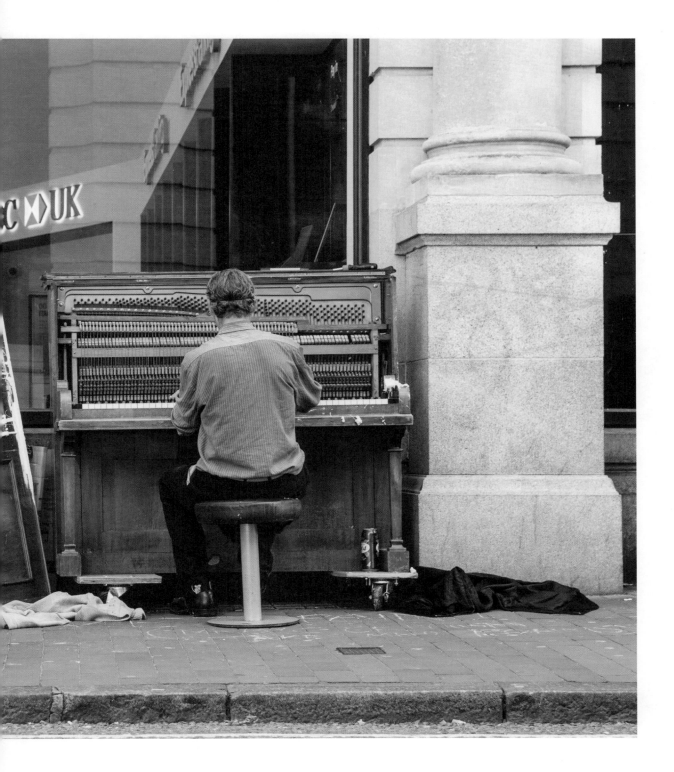

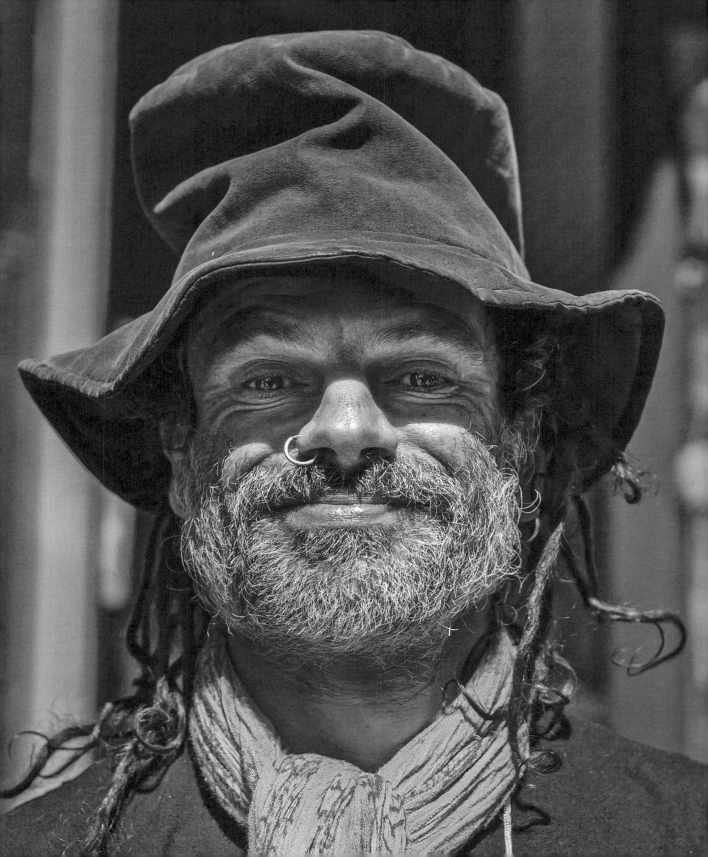

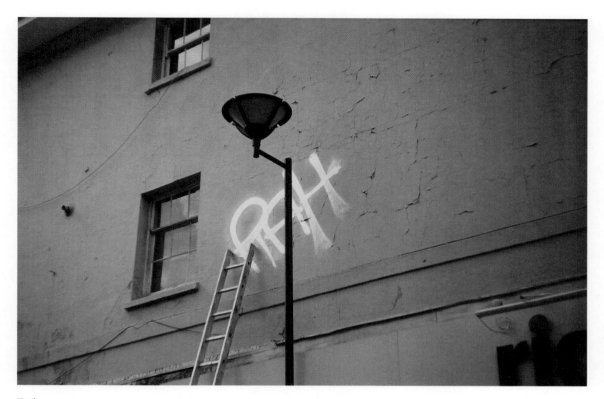

Rah

OPPOSITE:
Face full of stories

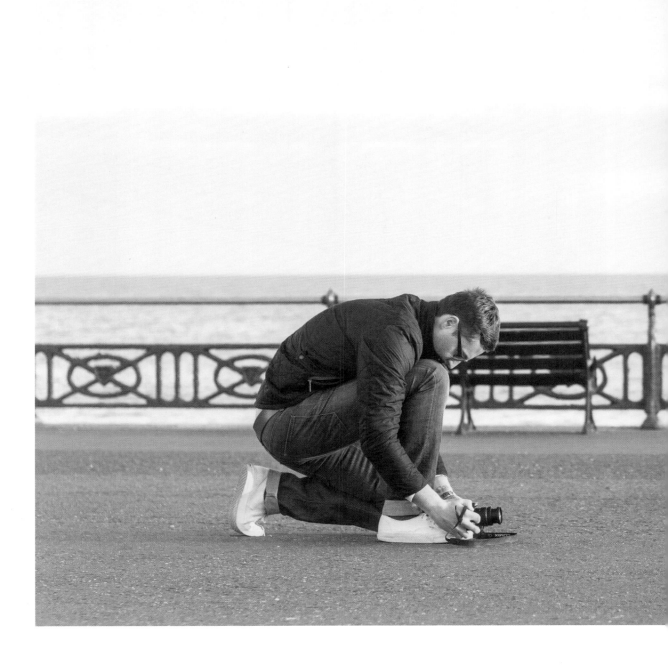

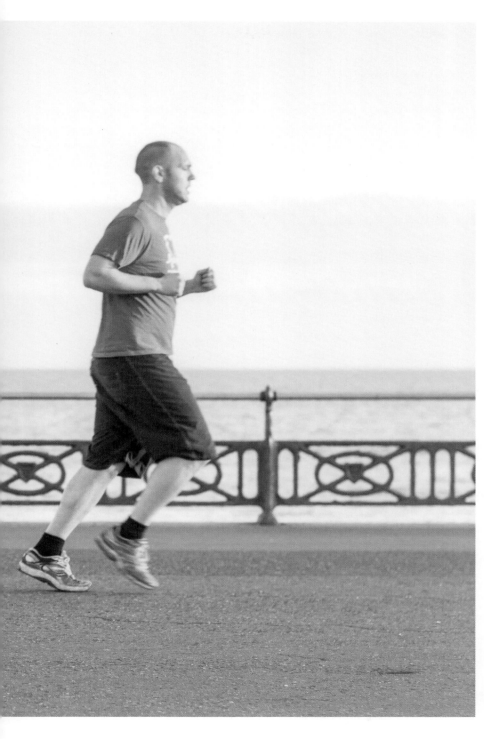

LEFT:
Photo finish

OVERLEAF:
Waveforms
Radio silence

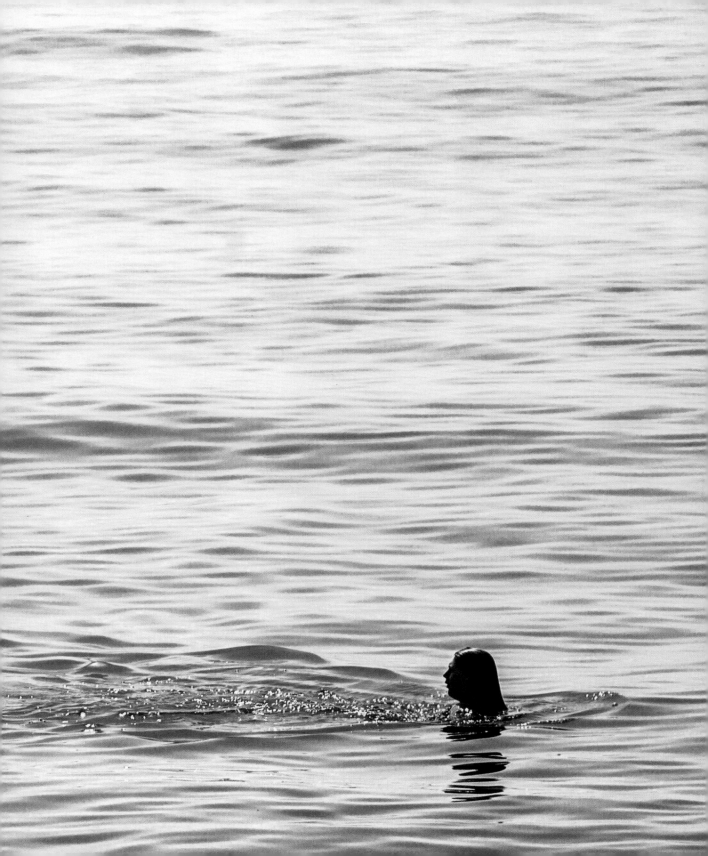

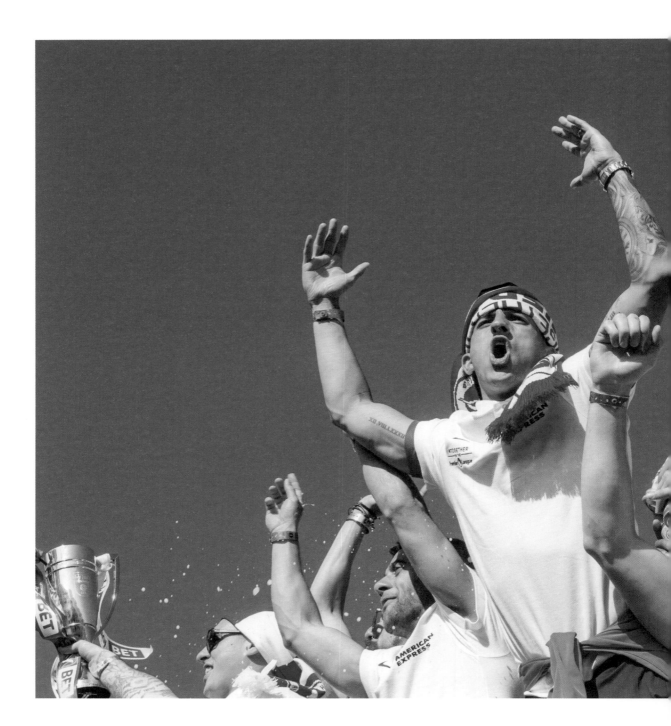

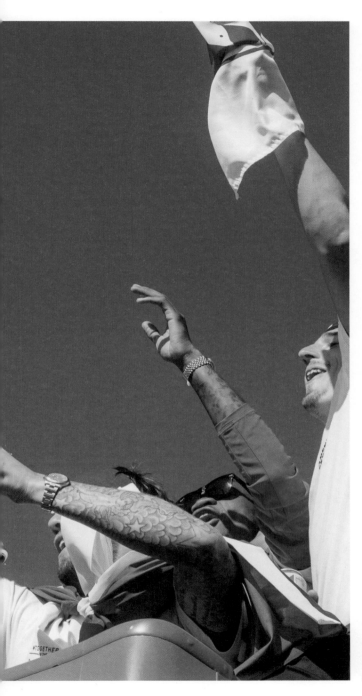

How big the deal is
Brighton & Hove Albion footballers
celebrating promotion to the Premier League

Neighbours

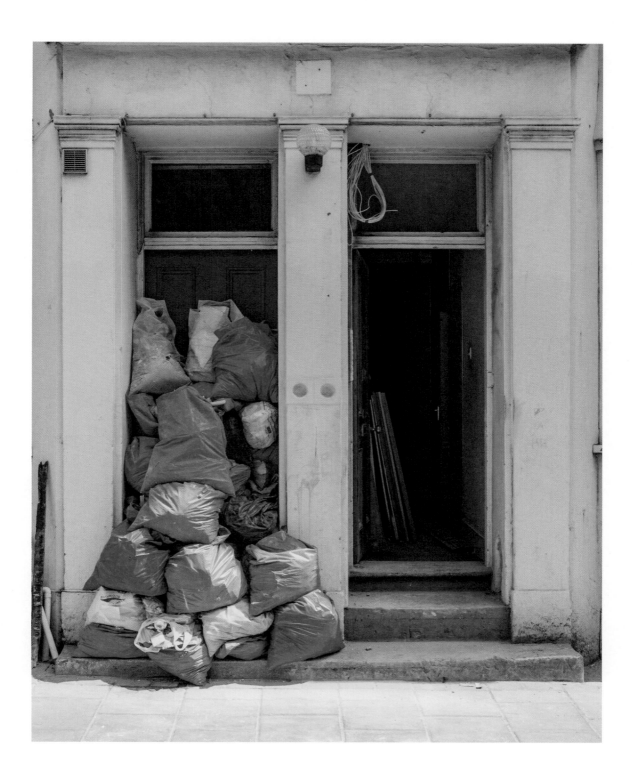

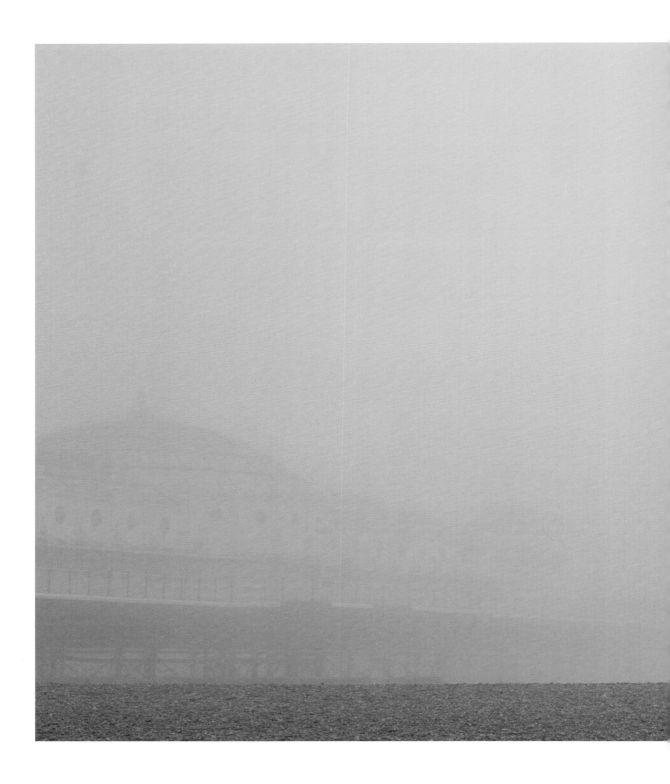

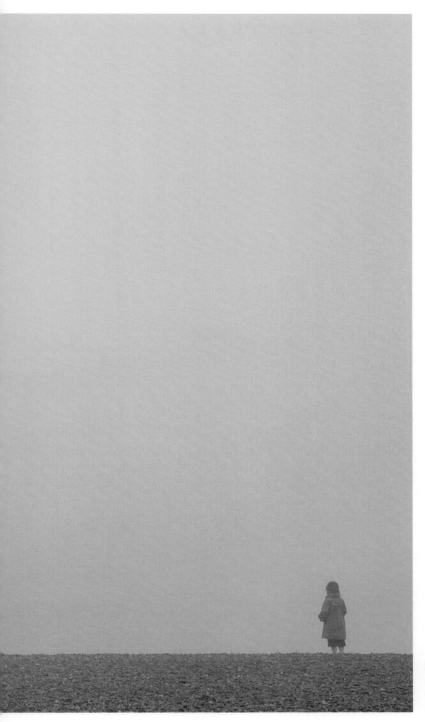

Forecastle
Brighton seafront is a surreal place
on most days, but on a foggy
day it's a whole different world

Southern comfort

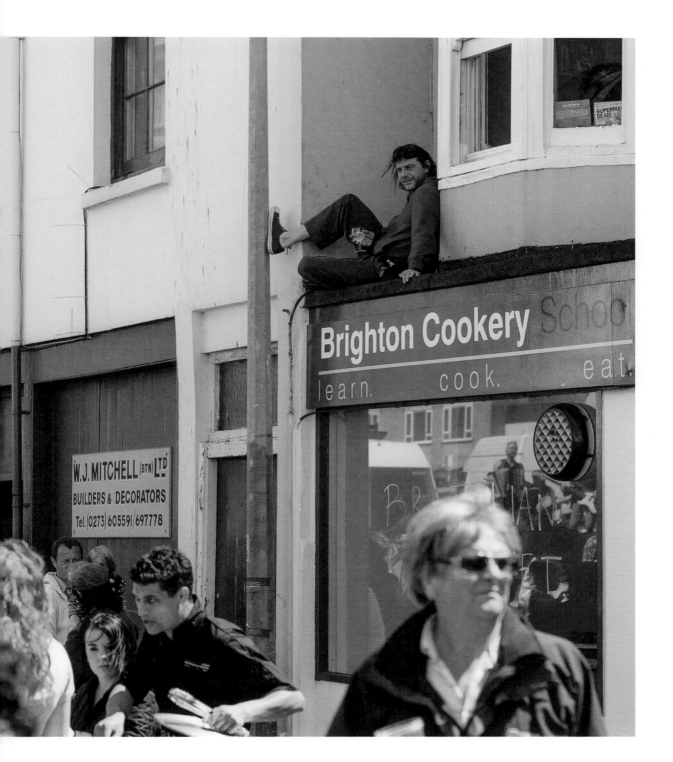

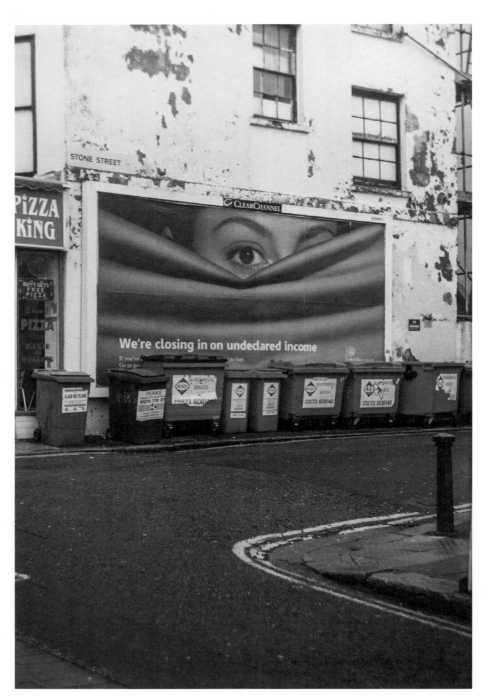

Fineprint
Always hidden

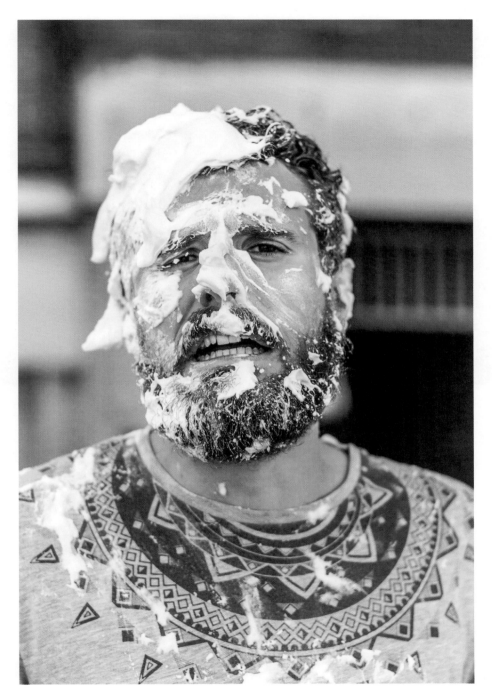

Foam party
Fun and games at the Kemp Town Carnival

Chivalry unwelcome

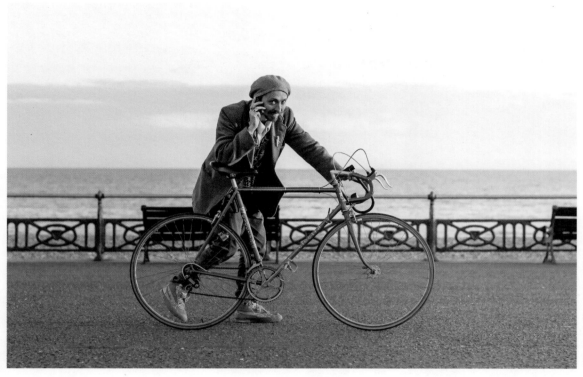

Fine specimen
Brighton resident taking his horse out for a walk along the seafront

OVERLEAF:
Knight-time
Imagine having to make that decision

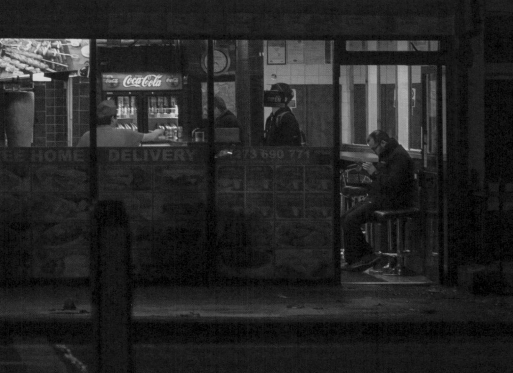

Chrome

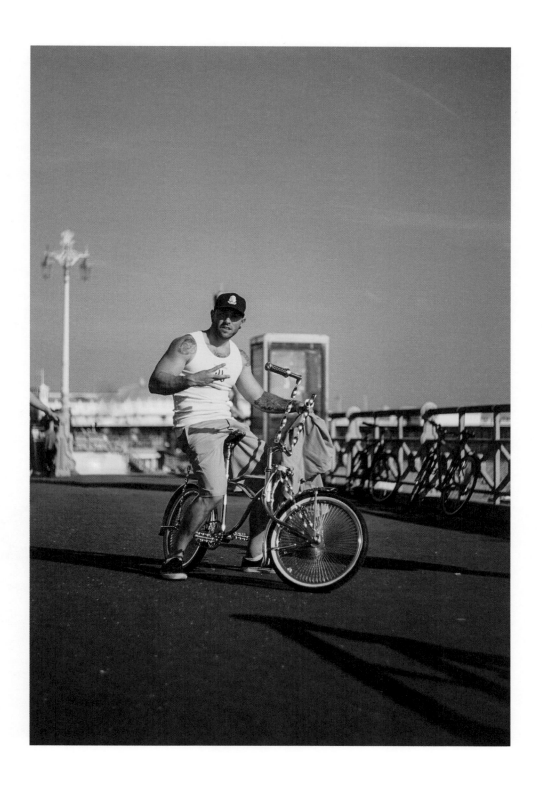

Stand out to fit in

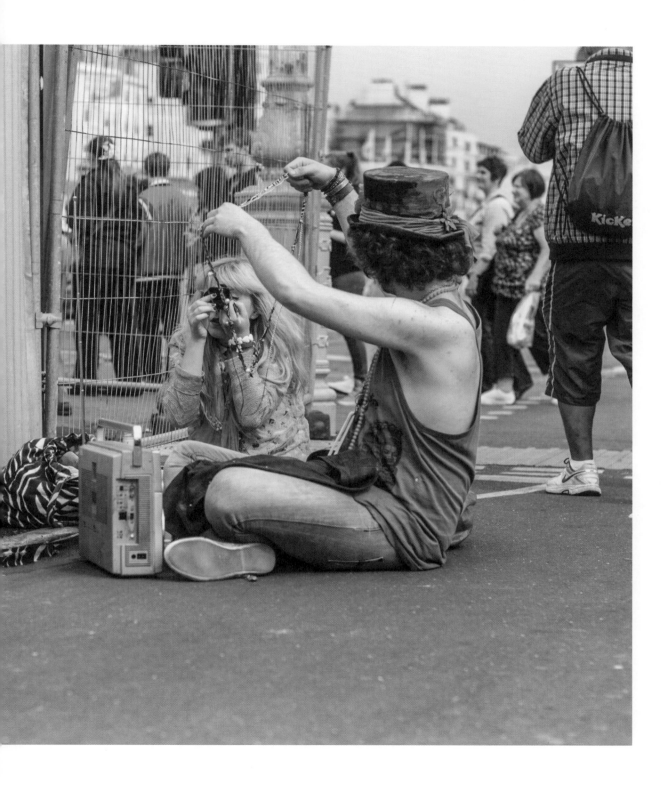

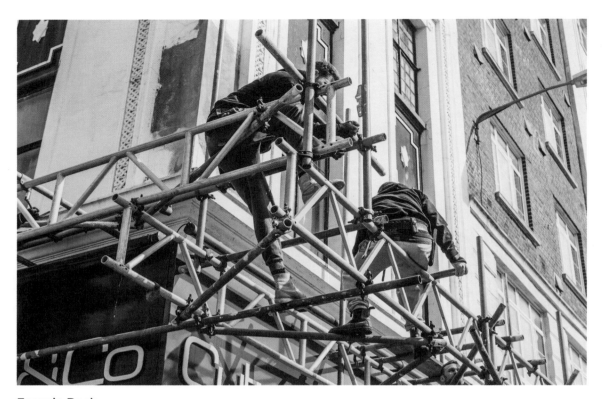

Fraggle Rock

OPPOSITE:
Analogue

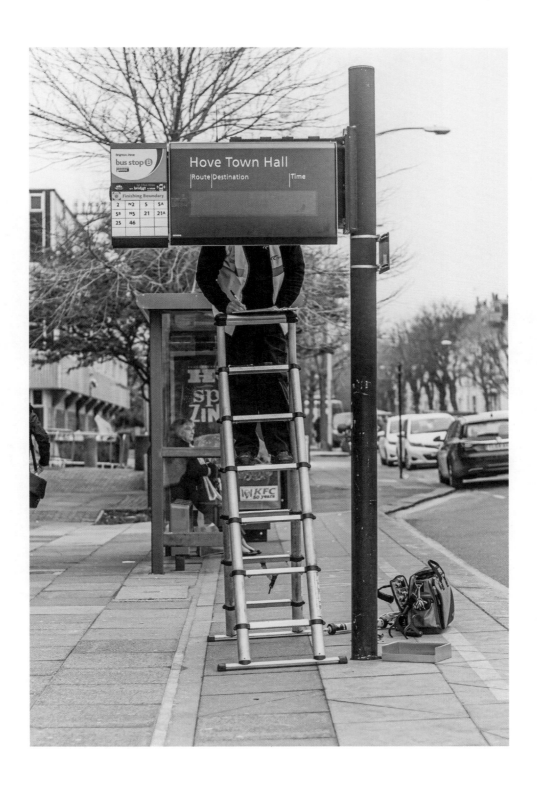

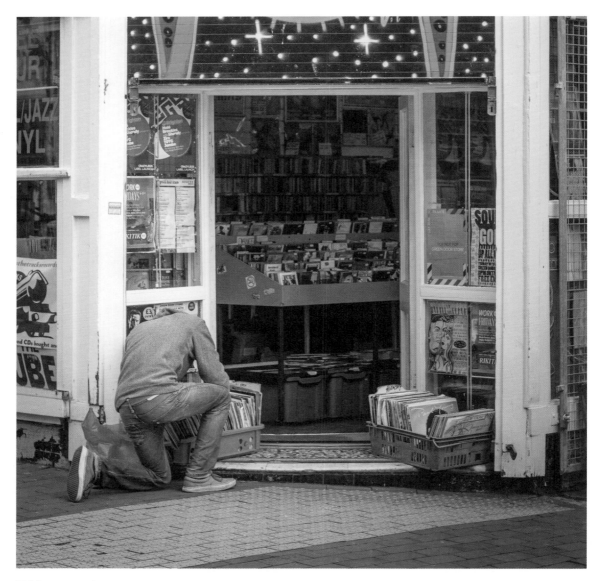

Taking samples
Digging through the cheap bins outside of Across The Tracks Records on Sydney Street

OPPOSITE:
Lathe
Working late into the evening

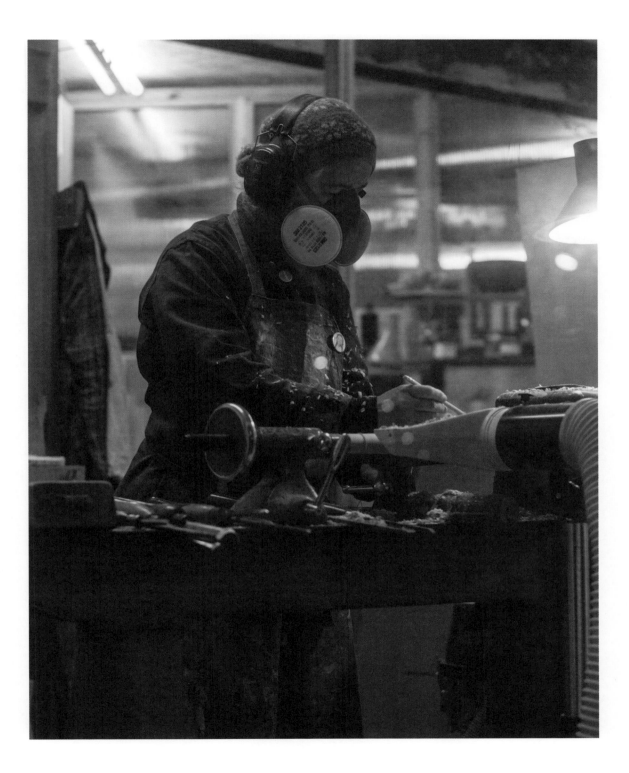

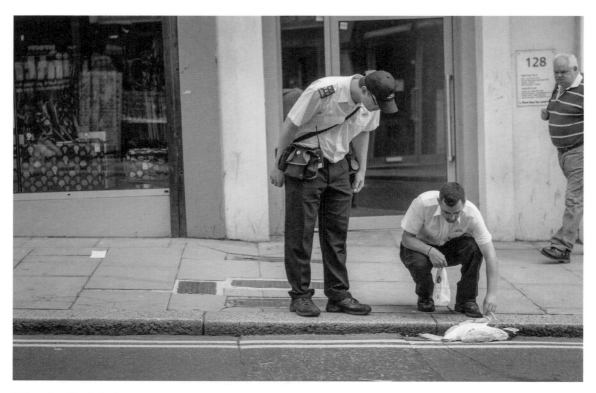

Wheels of misfortune

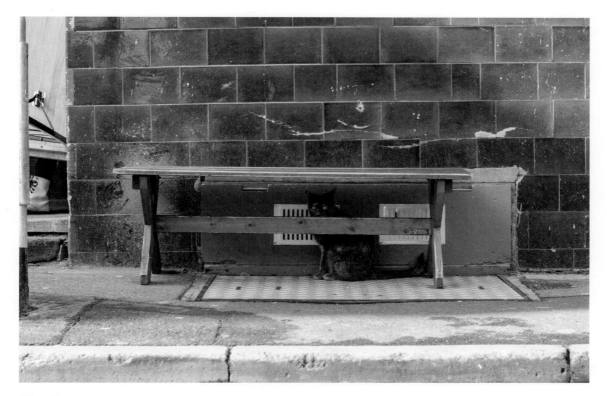

Wasn't me

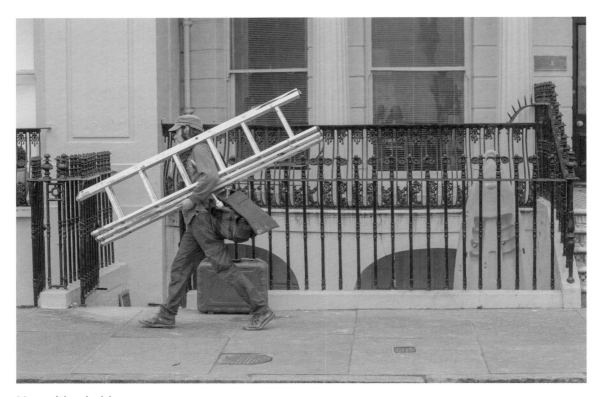

Man with a ladder

OPPOSITE:
Touch up

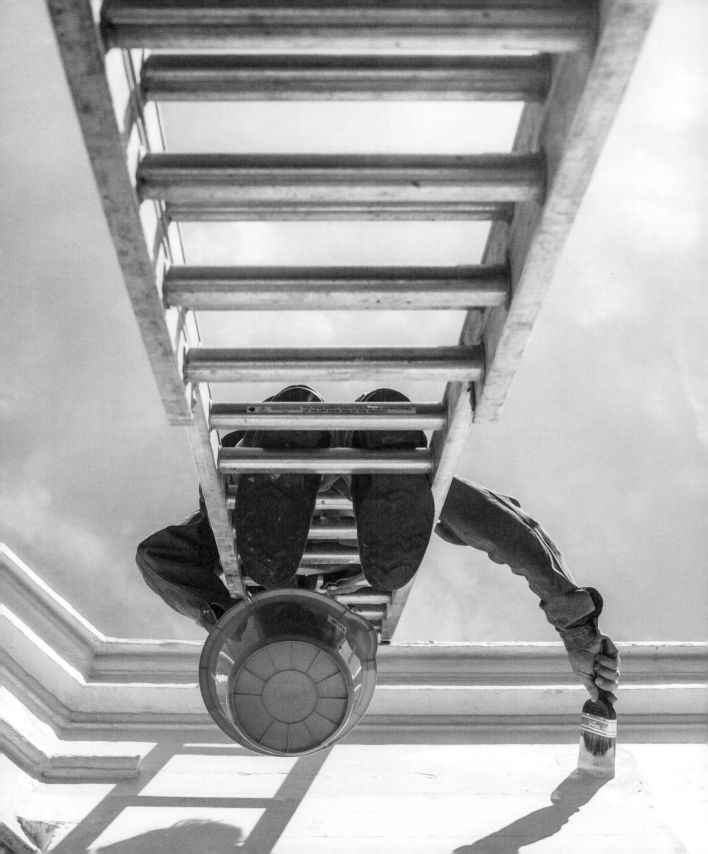

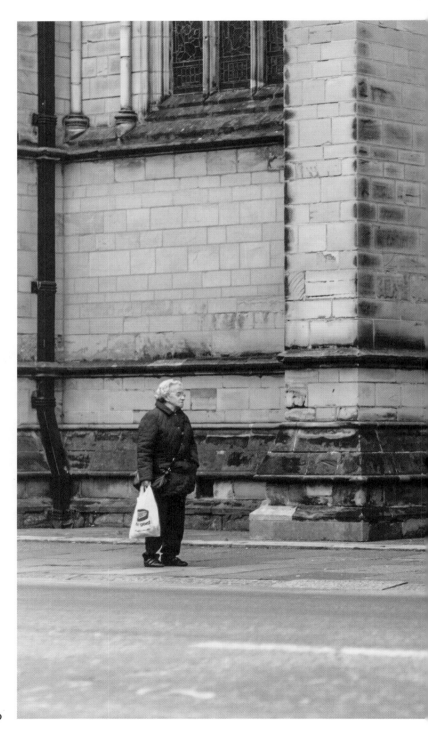

Crescendo

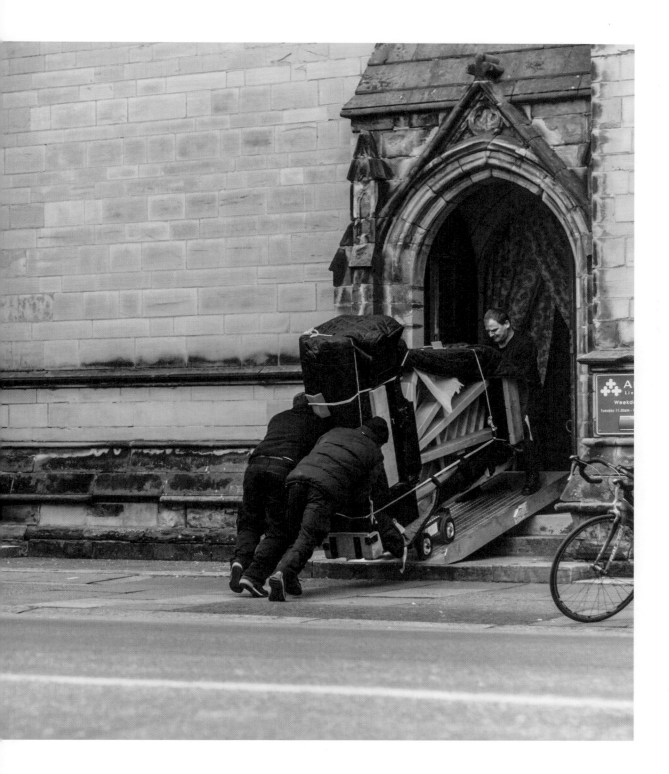

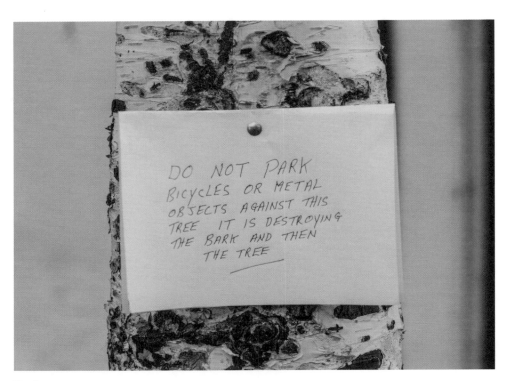

Bark

OPPOSITE:
Shadow of a man

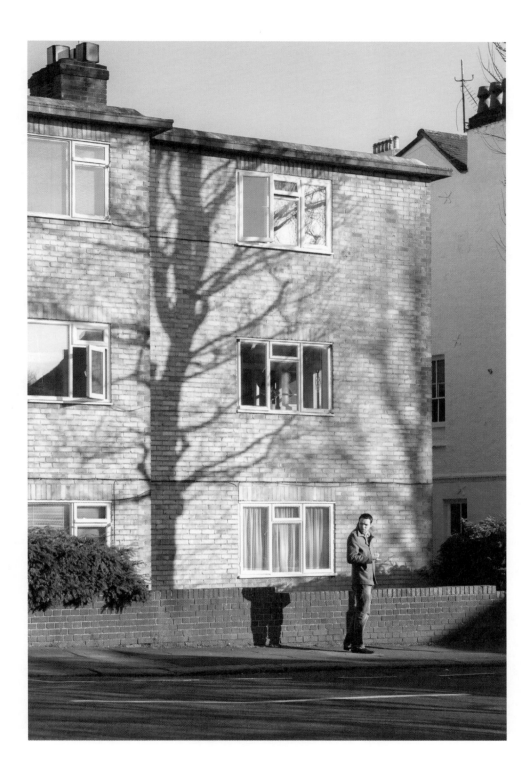

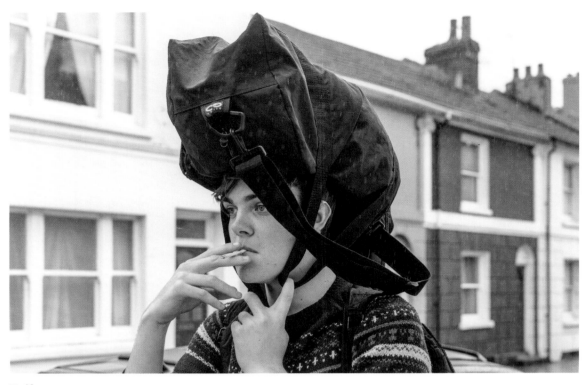

Half crown
Musician from local band, Half Crown, hiding from the rain and killing some time before his gig

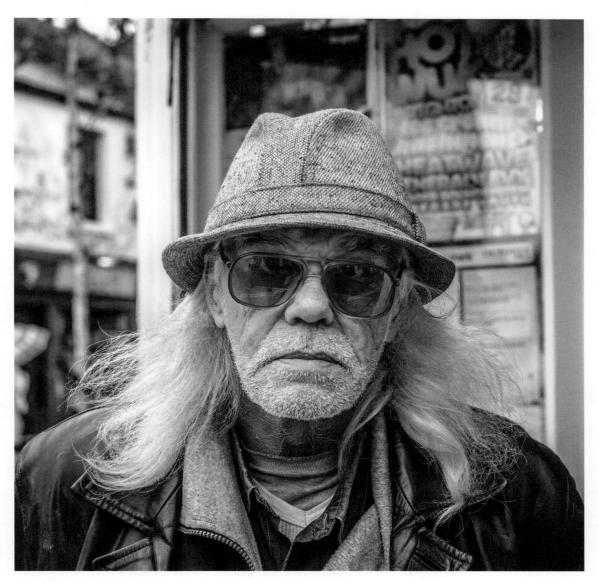

Gatekeeper

OVERLEAF:
Patricia and the dirty buoys

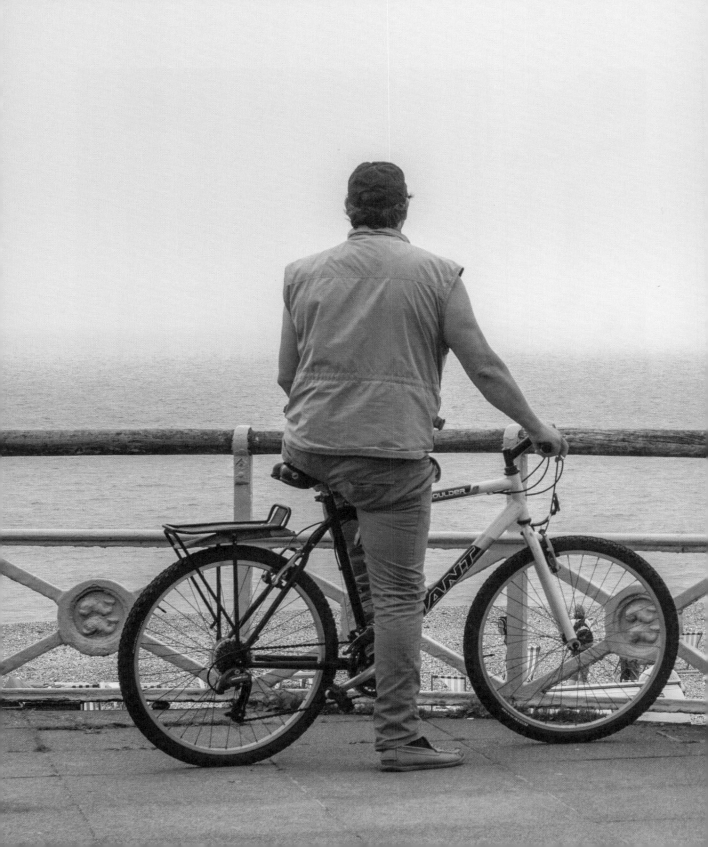

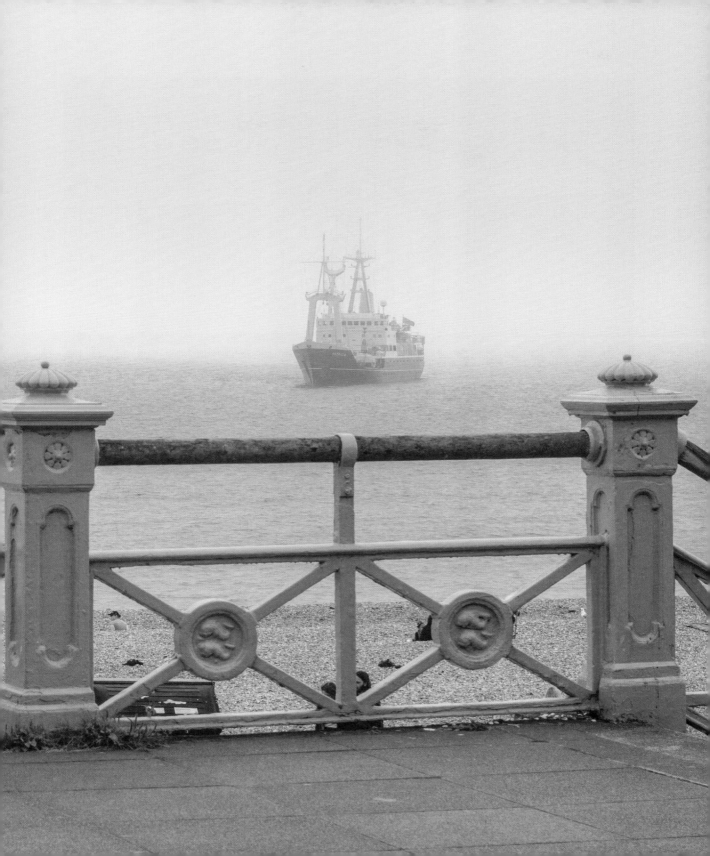

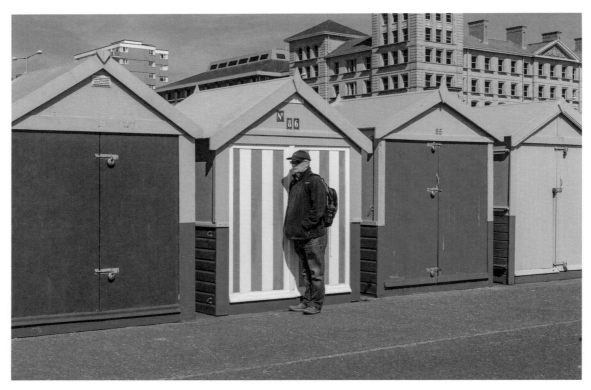

Chameleon
Now you see him, now you don't

OPPOSITE:
B is for bright

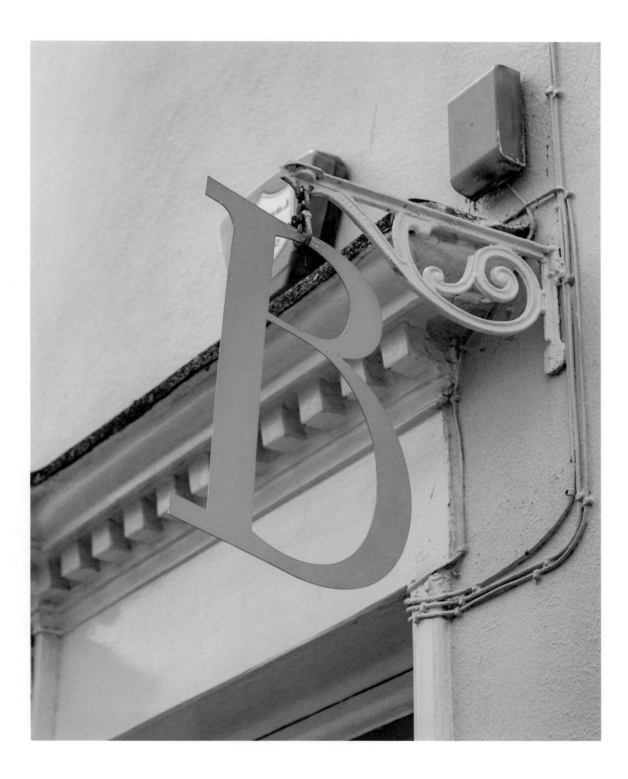

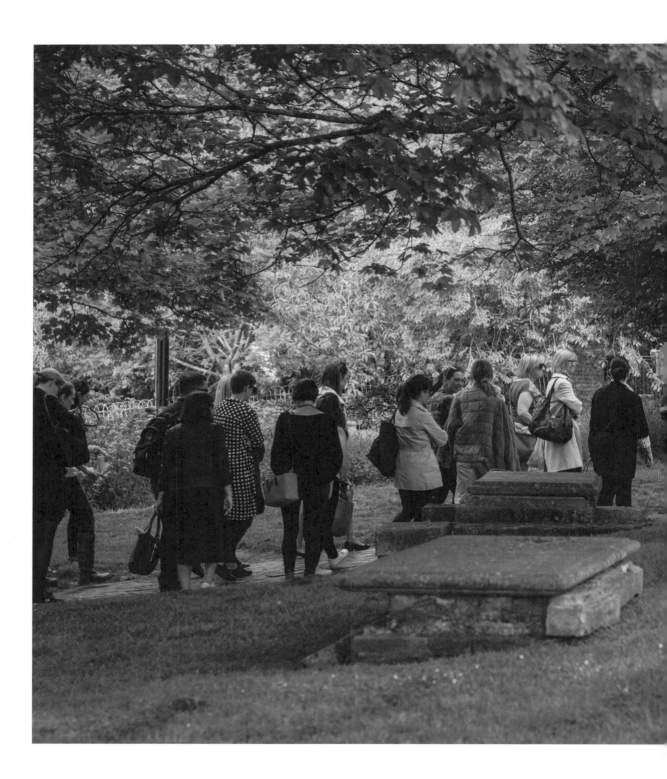

The Bachelor

RIGHT:
Bless you

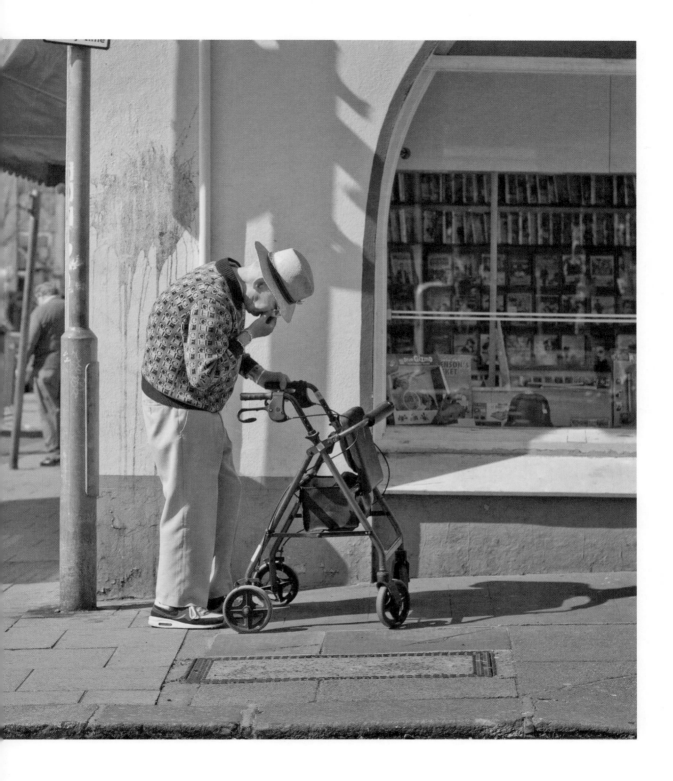

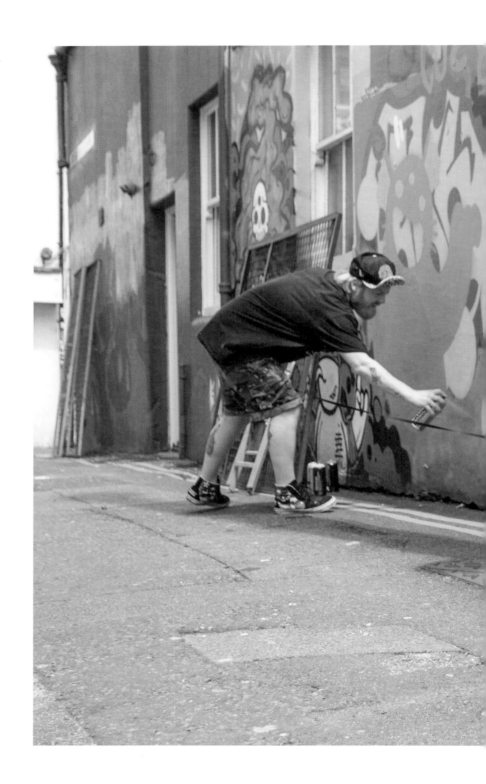

Partners in crime

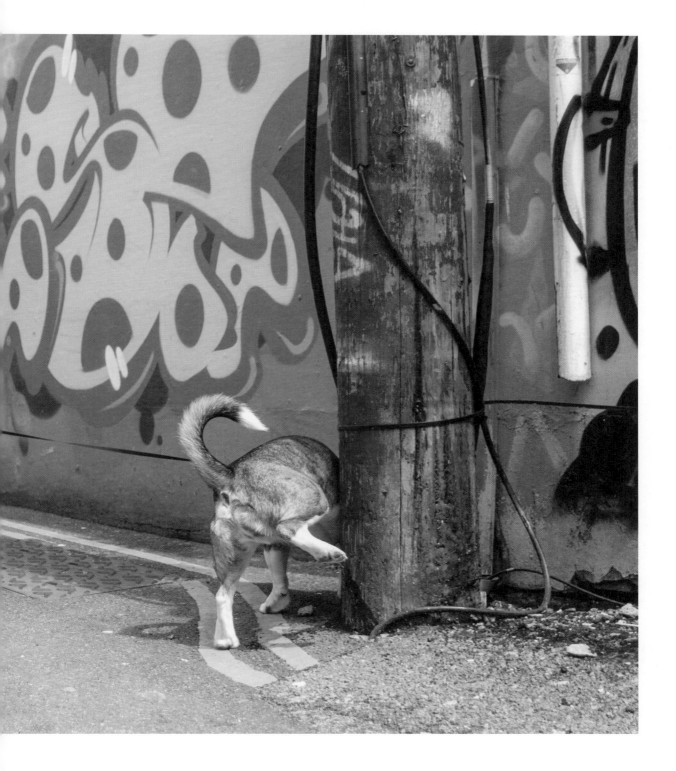

Head over heels

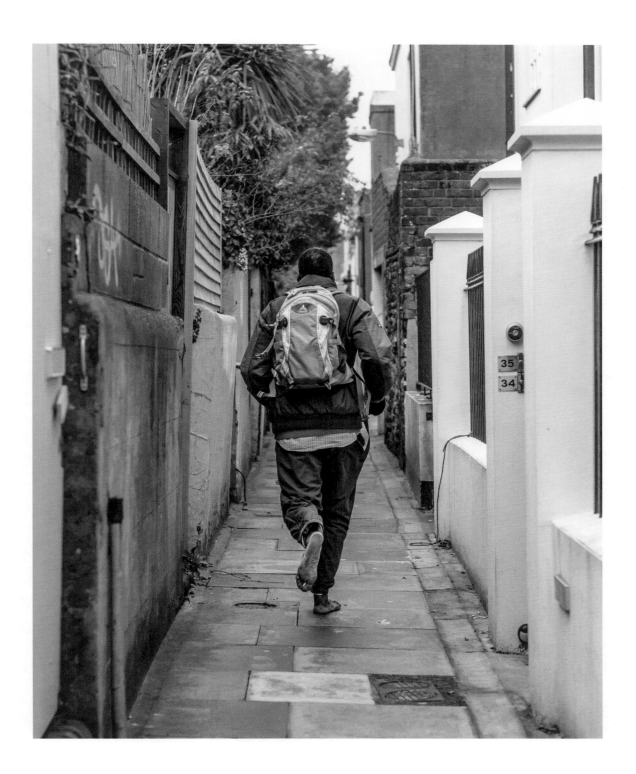

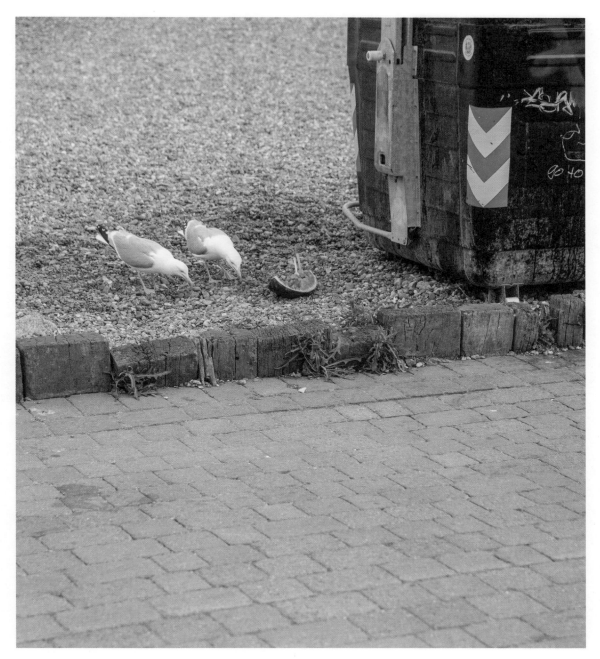

Exotic holidays

OPPOSITE:
Glass ceiling

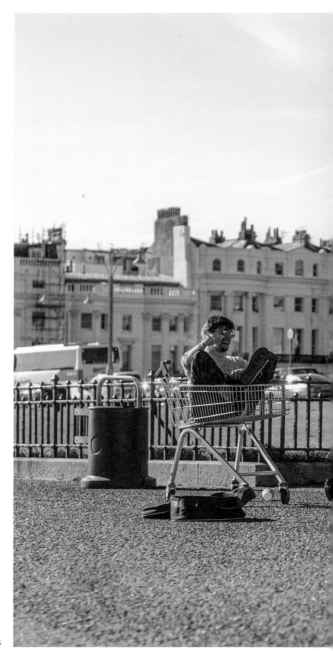

New Orleans

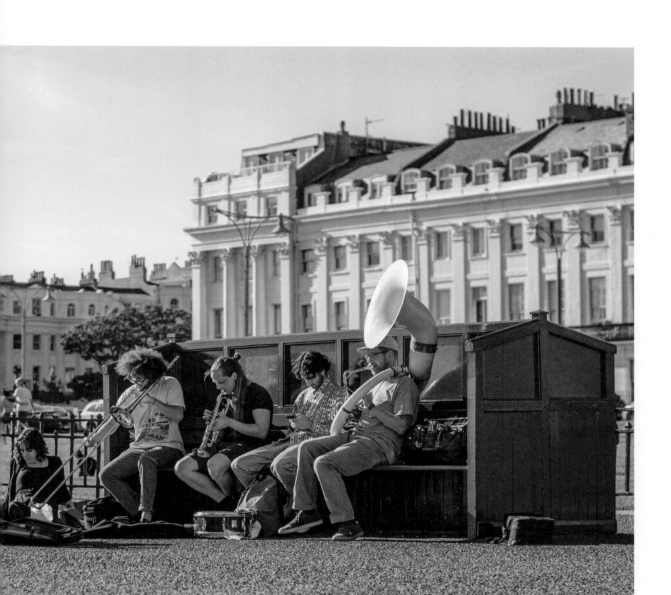

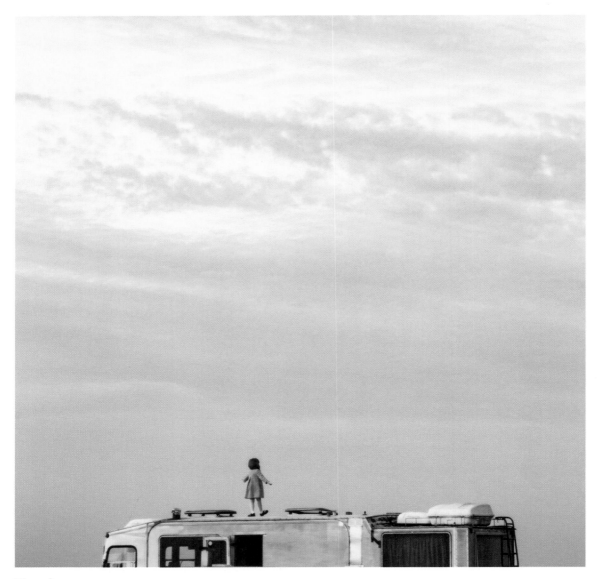

Tiny dancer

OPPOSITE:
Close friends

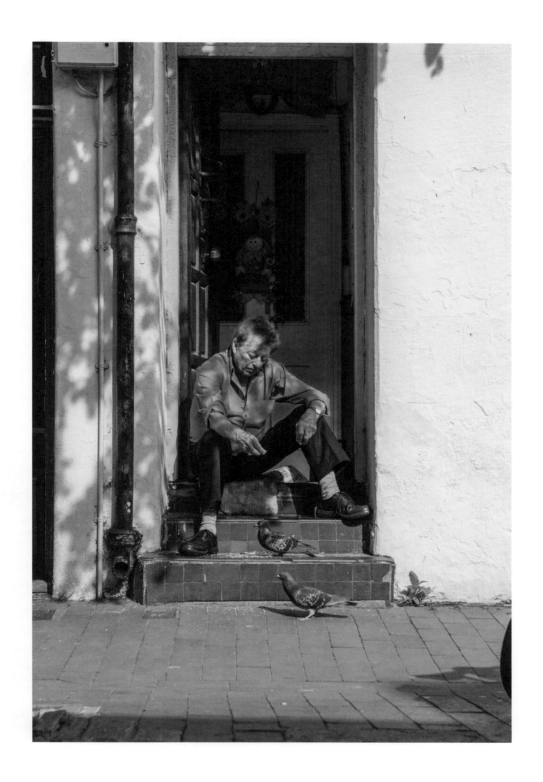

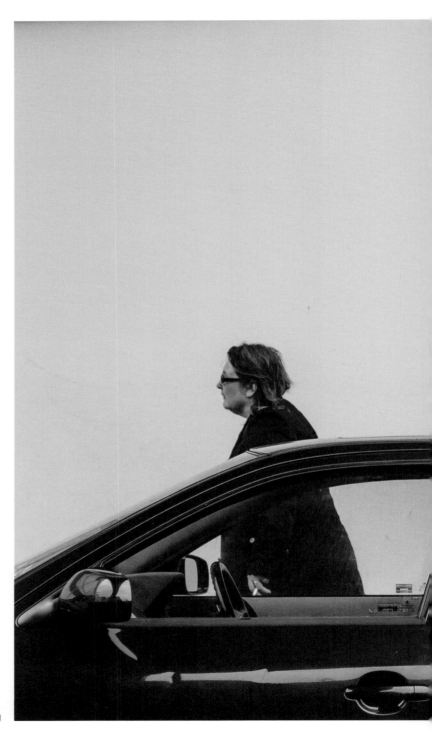

Guard dog

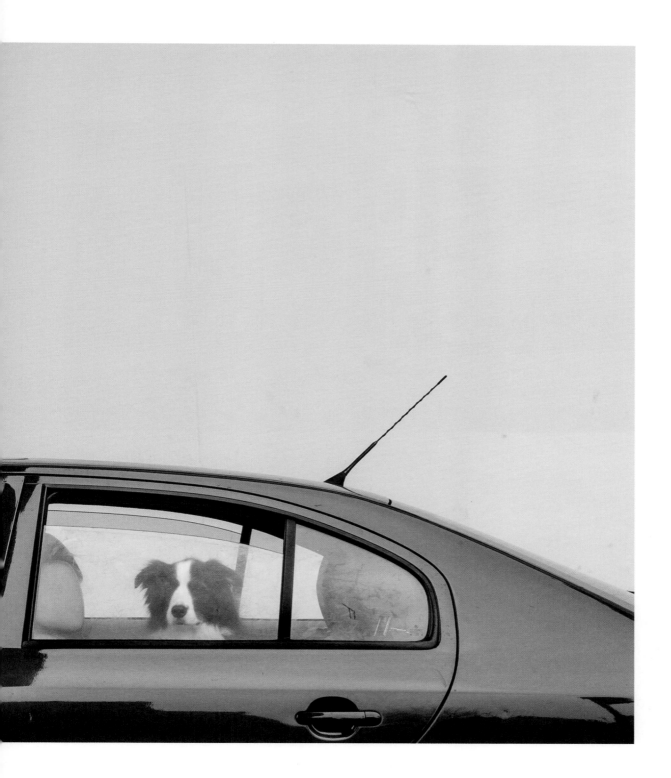

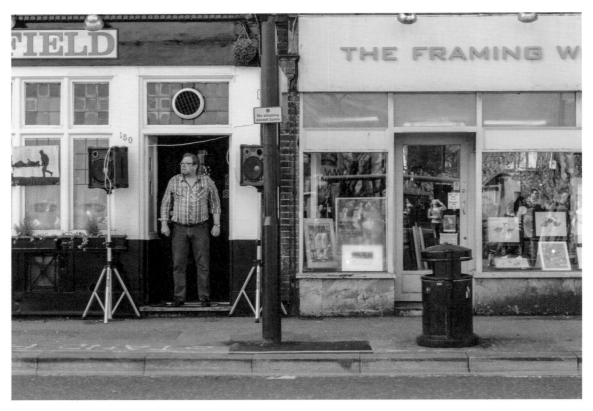

The Framing

OPPOSITE:
The picture within a picture

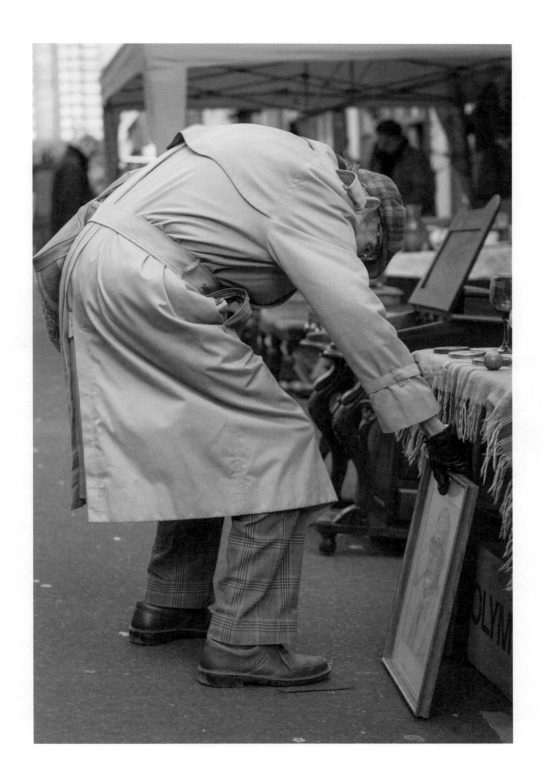

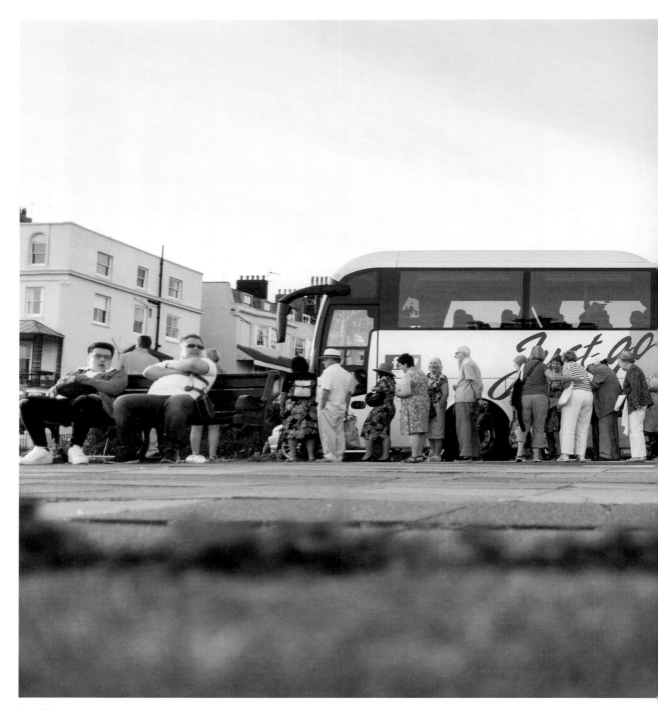

Packing up

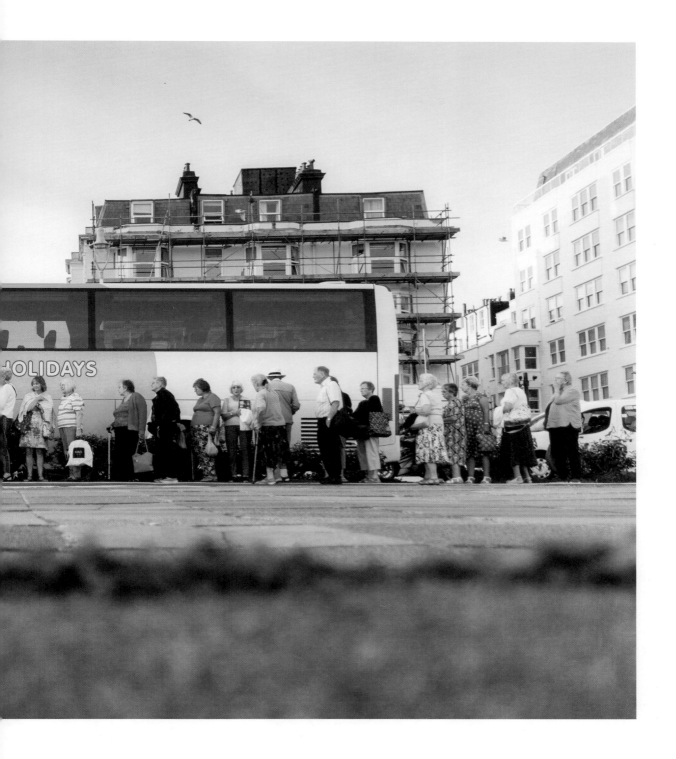

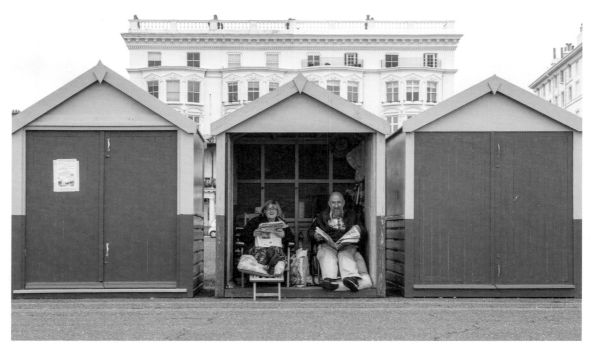

Hygge

OPPOSITE:
South facing. Sea views. Pet friendly.

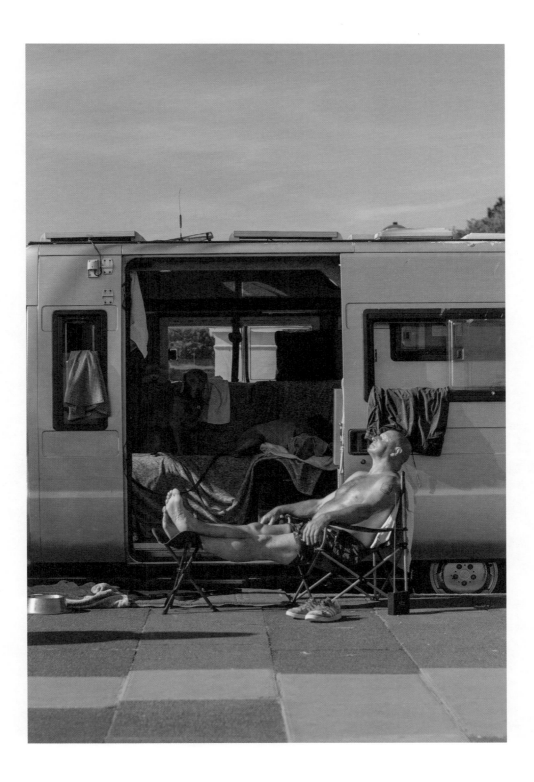

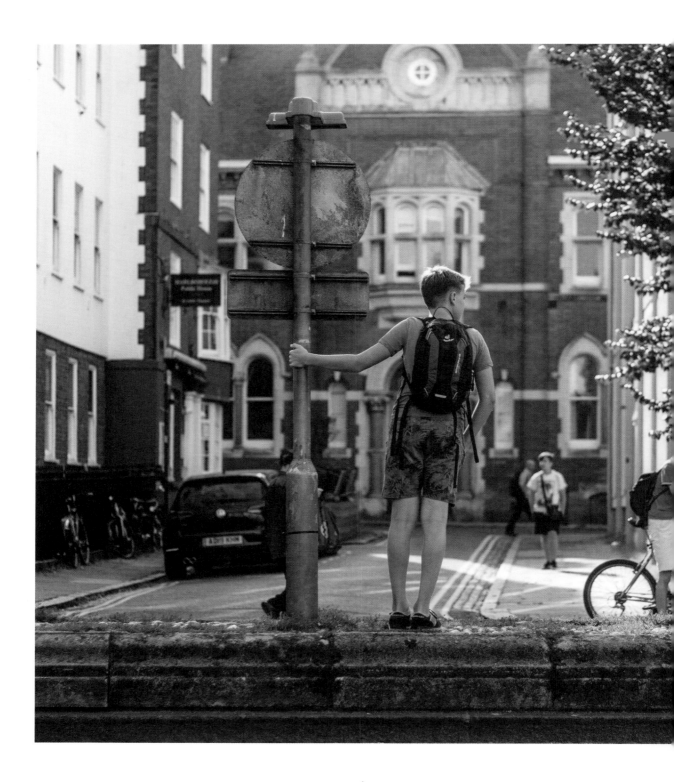

LEFT:
Jay

OVERLEAF:
Paddle Round the Pier

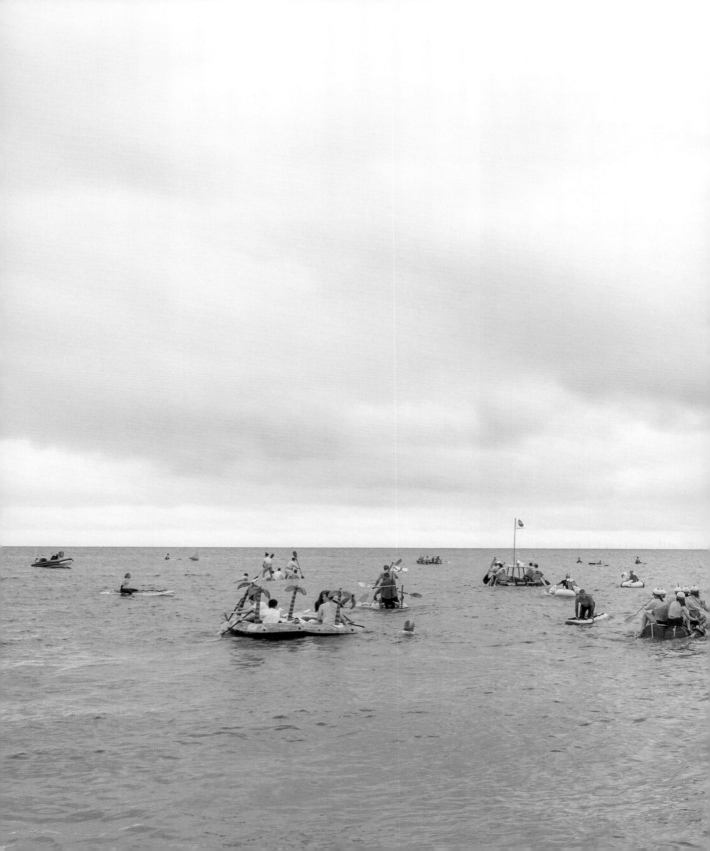

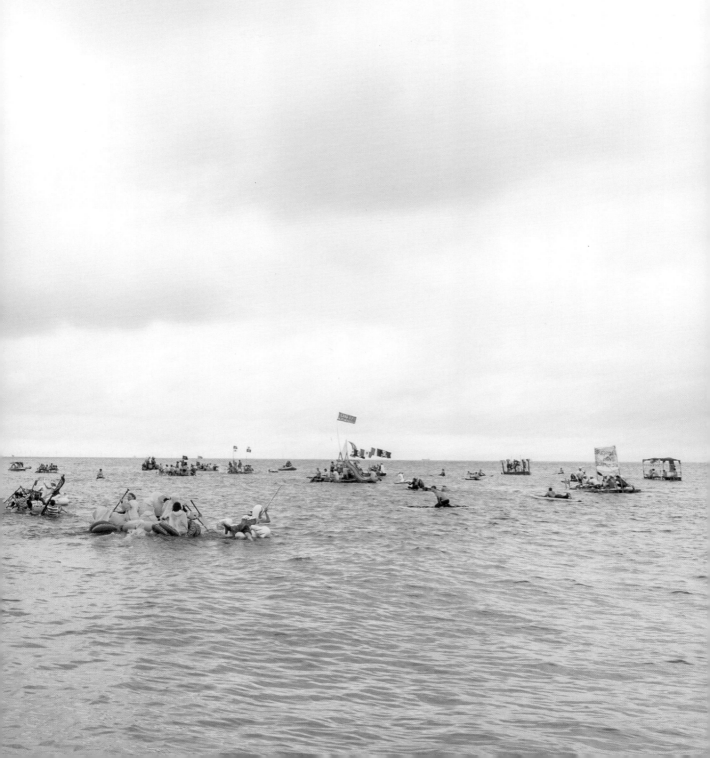

The History Press

The destination for history

www.thehistorypress.co.uk